CLYDE CONNELL

The Art and Life of a Louisiana Woman

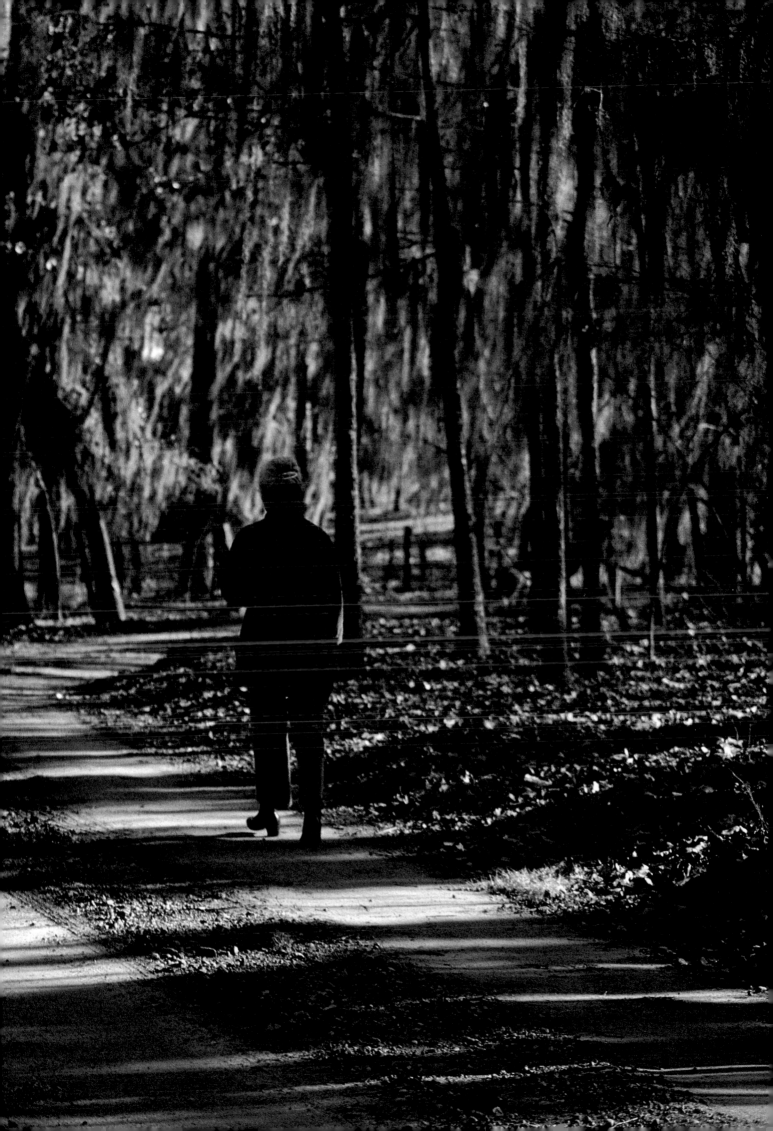

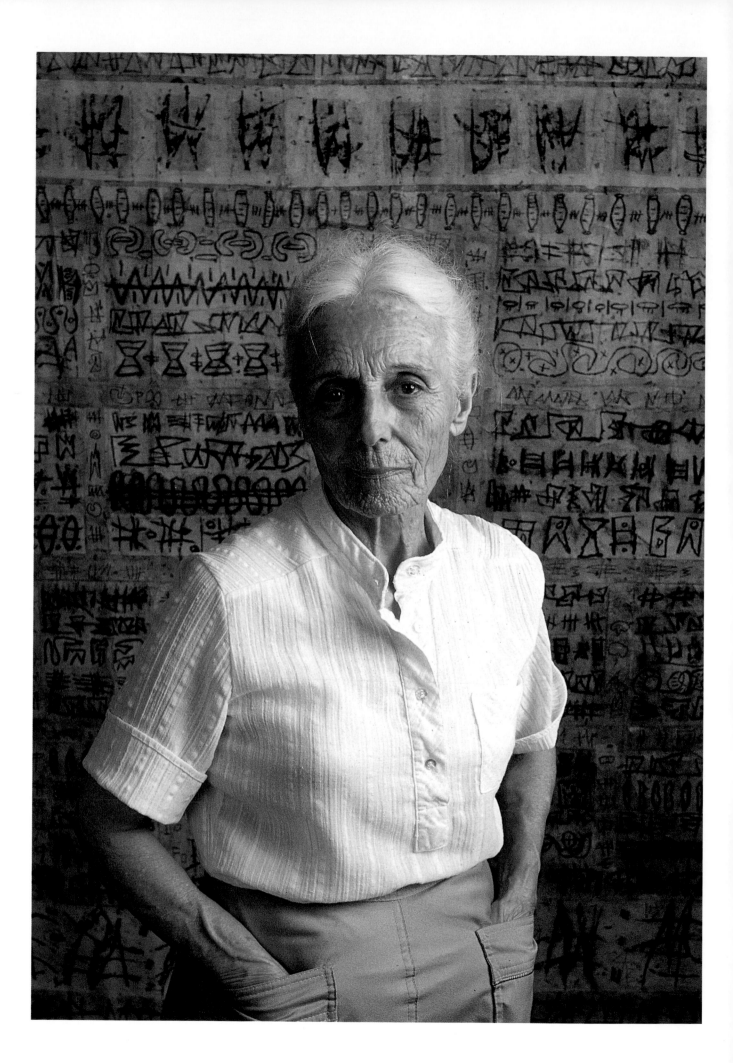

Clyde Connell
The Art and Life of a Louisiana Woman

By Charlotte Moser

University of Texas Press
Austin

The publication of this work
has been made possible in part
by a gift from Mildred Grace Tippett.

Library of Congress
Cataloging-in-Publication Data

Moser, Charlotte, 1947–
 Clyde Connell: the art and life of a Louisiana
woman / by Charlotte Moser. — 1st ed.
 p. cm.
 Bibliography: p.
 ISBN 0-292-71141-7 pbk.
 1. Connell, Clyde, 1901– .
2. Sculptors—Louisiana—Biography.
3. Sculpture, American—Louisiana.
4. Sculpture, Modern—20th century—
Louisiana. I. Title.
NB237.C614M67 1988
730′.92′4—dc19
[B] 87-30097
 CIP

Frontispiece:
Clyde Connell standing
in front of SWAMP SONG collage,
1982

Contents

For my parents,
Mildred and Charles Moser

Acknowledgments

I would like to thank the people who have provided support and encouragement for this monograph. Greatest thanks must go first to Clyde Connell, herself, who remained unflaggingly cooperative, generous, and good-humored throughout the duration of the project. Working with her was always a delightful experience. Mildred Grace Tippett, who with her friend the late Margaret Ann Bolinger has been a long-time supporter of Connell and her work, has provided crucial financial backing for the project, for which my gratitude is great. Many of Connell's friends provided encouragement during the writing of the monograph, particularly Lynn Randolph and James Surls. The assistance of Neil Johnson, John Fredericks, Martin Vandiver, Martha Dunphy, Ruby Little, Ann and Bryan Connell, Dr. and Mrs. Patrick Sewell, Mr. and Mrs. Willard Ent, and Betty and Richard Speairs was important both in providing background material on Connell and in facilitating the process of gathering material on her life and work. The commitment of the University of Texas Press to this project has been gratifying. Finally, for their support and understanding, I am grateful to my husband, Robert Benson, and to our children, Jonathan and Hannah, whose arrivals marked the beginning and conclusion of this project. Their presence made me ever mindful of the emotional textures that lie behind the spirit and content of Clyde Connell's art.

CHARLOTTE MOSER
Evanston, Illinois

And to find out what we are, we must enter back into the ideas
and the dreams of worlds that bore and dreamt us and there find,
waiting within worn mouths, the speech that is ours.

WILLIAM GOYEN
The House of Breath

When Clyde Connell was "discovered" at the end of the 1970s by the Texas art market, she had been working seriously as a full-time artist in northwestern Louisiana for almost twenty years. Connell was fifty-nine years old when she devoted herself to full-time art making in 1960, following a decade of increased commitment to mainstream art ideas during the 1950s. The conditions of Connell's "discovery," an artist of one generation found by the following one, are thus intriguing as a chronicle of the cyclical nature of art.

Adopted in the late 1970s as an eccentric artist whose work was the embodiment of postmodernism, Connell actually came of age as an artist in the years when modernist theory was first being written in this country. Because of an extraordinary first-hand contact with cultural ferment in New York after World War II, Connell completely absorbed the social and intellectual influences that produced a generation of artists concerned with the existential human dilemma. For her, abstract art with an underlay of social concern was the epitome of modernism, the idealized vision of human progress for a modern age. When such views subsequently fell out of favor in the art world, Connell nevertheless retained them, modifying her art perhaps to reflect changing trends but never wavering in her commitment to questions about human existence. Interest in the human condition has now returned to art. Connell, who might have once been seen merely as a marginal regional artist, is being given the status of a senior figure in contemporary art, an artist whose work reflects current issues seasoned by the wisdom of age.

At the beginning, Connell and her work elicited contradictory responses. The tantilizing thought of uncovering a southern Georgia O'Keeffe or a Louisiana Grandma Moses probably motivated journalistic interest when the telephone calls from the national press first started to come to Lake Bistineau in 1981. Television producers and magazine writers wanted to speak to this then-little-known eighty-year-old woman artist arousing such interest with her first one-person New York show at the Clocktower Gallery. They wanted to know who this woman with the man's name was, this original talent who had worked in solitude in the Louisiana bayous for nearly thirty years. They called her a folk artist, an "outsider" separated by age, sex, and region from mainstream art ideas.

Her tall somber primitive sculptures and abstract wall hangings told the art world otherwise. In 1984, at the College Art Association meeting in Los Angeles, the Women's Caucus for Art gave her the Distinguished Woman Artist Award. The New York art press began to compare her in 1985 with more famous women artists of her generation, Louise Bourgeois and Louise Nevelson. In 1986, Connell was among ten artists nationally chosen for an Award in the Visual Arts from the Southeast Center for Contemporary Art. She was honored in 1987 by the National Sculpture Conference in its Works by Women exhibition. The Hirshhorn Museum in Washington, D.C., featured her work in 1988 in an exhibition called Different Drummers.

Like the "discovery" of Connell, the accolades bestowed on her and her work are also ironic, because she did not set out to be an American artist of such note. For nearly forty years, she lived the routine life typical of any homemaker in an American farm town: rearing children, maintaining an extended family, and participating in women's groups and local church activities. Despite occasional excursions to larger cities around the country, personal contact with the outside world of ideas always required effort for Connell, who has lived her entire life within a fifty-mile radius of Shreveport. Yet, like William Faulkner, the Mississippi writer whom she often cites as an important influence, Connell has transformed her regional experiences into tools to shape an original visual statement about the human condition.

This monograph is premised on the belief that, to quote the anthropologist Clifford Geertz, "the means of an art and the feeling for life that animates it are insep-

arable."* Thus, the facts of Connell's life and the art that it influenced will be examined. An appreciation for history and the progress of humankind through the trajectory of time was palpably present in Connell's upbringing. Born in 1901 as a privileged white plantation daughter, she grew up hearing stories from her South Carolina–bred grandmother about the Civil War and the horrors of social disenfranchisement brought on by the Reconstruction. Throughout her life, she remained sensitive to the pain of cast-aside rootless social groups. At the turn of the century, when much of the rural South remained virtually unchanged from post-slavery days, she was surrounded by black culture and the conservative mores of the Victorian era. By the 1930s and 1940s, when the primitive art of Africa and Oceania was influencing vanguard artists in Europe and New York, Connell had a primary experience of a primitive culture closer to home. In the 1960s, childhood influences from Afro-American culture re-emerged as major components for her art, first as subject matter in an expressionistic version of social realism and then for its affinities to primitive art. The sounds of black voices, singing or mourning, made an indelible impression on her as the sound of basic humanity, a metaphor that shaped much of her mature work.

Connell's plantation background, combined with her childhood love of English romantic poetry, further contributed to the prominent role of nature in her work, both physically and philosophically. Eventually viewing herself and all humanity as part of the unity of nature, she evolved a philosophy that emphasized the redemptive quality of nature. The flotsam left by time and nature on the plantation—rusty farm machinery parts, gates and fence posts, Spanish moss, swamp vines, Louisiana clay—all became part of her visual vocabulary, used to describe her own moment in history where past participates in the present.

* Clifford Geertz, "Art as a Cultural System," in his *Local Knowledge*, p. 98.

An important chapter in the development of Connell's artistic identity concerns her thirty-year involvement with the educational programs of the Southern Presbyterian Church. Starting out in 1931 as a teacher in the Vacation Bible School of the local black Presbyterian church, Connell entered the Leadership Training Program of the Presbyterian church at a time when major changes were beginning to take place in American Protestantism. In her church training, she was exposed to advanced educational and philosophical theories by such thinkers as John Dewey, Paul Tillich, and Rabindranath Tagore, whose works provided the intellectual grist for her future questions about human existence. Serving as a southern representative to the progressive National Council of the Churches of Christ in New York from 1954 to 1962, she personally participated in civil rights struggles in the South during the 1950s. Her bi-annual council meetings in New York also put her into contact with the artistic ferment of the 1950s in New York, much of which echoed the intellectual questions prominent in theological circles.

Finally, as her artistic interests matured, Connell has been influenced by individual figures and trends in contemporary art. Through surrealism of pre–World War I Europe, she discovered the psychological power of the "objet trouvé" and collage. Abstract expressionism, as a painterly American outgrowth of surrealism, played a seminal role in her first efforts as a modern artist. The work of feminist artists like Eva Hesse and Judy Chicago, like the women's art movement in general, gave her courage to explore emotional terrain she might otherwise have overlooked. She thinks of herself now more as a rationalist than an expressionist artist, citing such conceptual artists as Sol LeWitt as important influences. Clearly, unlike the traditional folk artist, Connell has never considered herself an "outsider" artist but a confirmed "insider" actively current on contemporary art theory.

Connell, in her mid-eighties a bright, diminutive woman with an elegant coil of

white hair, projects the spritelike presence of a gentle mystic. Largely unchanged by her new and unanticipated position in the national art scene, she speaks more easily about her wide circle of family and friends than she does about art. The studio-house on Lake Bistineau where she has lived since 1959 lies some sixty miles from Belcher, the farming community in neighboring Bossier Parish where she was born and where she lived with her mother, husband, and children in the family plantation house for almost fifty years. With the flair of a southern raconteur, she talks about her flamboyant plantation father and her fashionable mother, who died in 1976 at the age of ninety-nine. Her childhood along the Red River and her college days during the Jazz Age are idyllic memories of a by-gone era. Other memories are not so happy. The difficulties of living in a racially and socially bigoted region and the decisions it forced in her early and middle adult years remain keenly felt even today. The loss of family land during the Depression and the humiliation of adjusting to a lower standard of living are painful to recall. Connell has outlived one of her three children, her husband, and two generations of friends. Nevertheless, Connell's spirit remains youthful and resilient, made somehow ageless by her artist friends, many of whom are now nearly a half-century younger than she.

Connell's main concern remains finding enough uninterrupted time to make all the work she wants. "I don't want to be media-made. I want to be known for my art," says Connell, explaining that she turned down an interview on the popular television show "Good Morning America" because it conflicted with attending a sculpture conference. Such clarity of intent—and surely the wisdom of her years—has helped keep alive her natural

good humor in an art world known to take itself too seriously. On the bookshelf in her studio is a black-and-white photograph of her chatting with New York art mogul and gallery owner Leo Castelli during the opening of her Clocktower show. Gazing at it, she chuckles as though recognizing a private joke. Then eighty years old, she is positively regal in the photo. Her head, with its crown of white hair, is thrown back, her chin thrust forward so that her half-lidded glance at Castelli is the apex of hauteur. "My mother used to hold herself that way," she muses, swiftly reducing what could have been an intimidating situation to a familiar family reference.

If it is true that the history of art is the history of people who make art and not the history of objects, then Clyde Connell and her art come full circle. For nearly sixty years, from her birth in 1901 until her retreat to Lake Bistineau in 1959, Connell's life was extraordinary principally for the rich veins of southern social history that ran through it. She embraced art as a full-time occupation at a time when many people enter retirement, inspired by more than half a lifetime of ideas and experiences sustaining her into old age. In fact, it might be said that Connell's first art has been, to paraphrase Paul Tillich, finding the metaphysical hidden in the "apparently trivial thing," the things from the "here-and-now" of daily living that define existence.* Such awarenesses are not easily swayed by passing fashion. They are enduring and, in the case of Clyde Connell, have yielded artwork that rings true and eternal.

*Paul Tillich, quoted in *Paul Tillich's Philosophy of Culture, Science, and Religion,* by James Luther Adams, p. 98.

13

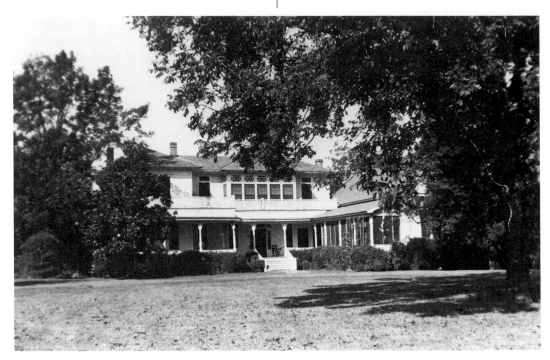

Dixon House, Belcher, Louisiana,
ca. 1935

Plantation Life, 1901–1949

Clyde Connell rarely misses a sunrise over Lake Bistineau. For many years, coffee cup in hand, she welcomed the day from the rickety fishing pier built into the lake behind her studio. There she would sit in an old metal lawn chair watching the clean pink light wash over the night-black water, waiting for the buzz of awakening wildlife. The yellow metal sculpture on the bank next to the pier was usually first to catch the sunlight, reflecting a glowing pattern of wavey lines back up to the heavens. When Connell placed her sculpture there in the early 1960s, it was an experimental piece she called *Sunpath*. The work remains there still today. A landmark to bayou fishers, it is Connell's modest sign of thanks to the gods above for each new day, a shimmering symbol of her own enchantment with life.

When she moved to Lake Bistineau outside Shreveport in 1959, the property was as barren as her life then seemed. At the age of sixty, she had been forced to leave behind an active, engaging life to move to this remote cabin and an uncertain future. Gone was her involvement with the ecumenical church movement and the social activism for which she had traveled throughout the South for nearly twenty years. Also at an end, it seemed, was her progressive leadership in the flowering Shreveport cultural scene. But two things she still possessed: a rich reservoir of memories and her art. The memories, both sweet and sad, resonated now with intensity. In the best southern tradition, her past had been flavored by the colorful history of plantation life at the turn of the century. Through everyday contact with black culture, she had first been moved by the emotional and religious fortitude of black people and then deeply troubled by their abuse. Her life had been one of social conscience, a life of going against the grain. Art had been her solace for many years, and now, left with her memories, she turned to art as though to breathe new life into her existence. In the end, it was all that she needed to start over.

The wide lawn down to the fishing pier began filling up with what looked like mystical sculpture about a year after Connell moved to Bistineau. Over the next three decades, several different styles of sculpture, each building on its predecessor, flowed steadily from the concrete-block house to the back and side porches and out to the lawn amid the tall cypress trees draped with Spanish moss. First were the bright flat geometric sculptures like the *Sunpath;* then came the tall gray spindly figures whose crusty skin was imbedded with rusting nails and machine parts. Strange tall obelisk sculptures, scribbled with mystical writing, followed. The last to come were more like dwellings than sculptures, forest huts emblazoned with the same mystical writing and studded with pebbles. Thirty-five years later, the walls inside the house were equally covered with paintings, collages, and drawings tracking in two dimensions the sculptures outside.

Over the years, the house itself had been transformed into an art-centered world. When Connell designed its floorplan and supervised construction of the concrete-block structure, she had not known how art would take over. What she had originally intended as the studio eventually became a sitting and reading room. The studio was moved into the large screened porch, weatherized and heated with a potbelly stove for year-round use. Connell slept in the studio and, until he died in February 1985, her husband of sixty-three years, T. D., used one of the two bedrooms. The rest of the house, except for the kitchen, became storage and exhibition space. Inside the house, one can also see signs of Connell's childhood: an old sleigh bed that her grandmother brought from South Carolina after the Civil War; a heavy wood table hewn by one of her four brothers; some realistic woodcuts and paintings clearly from another era, darkened by time. The viewer is drawn toward one small, evocative oil painting depicting an event that Connell had witnessed nearly a half-century ago at the Caddo Parish Penal Farm. It is a scene of

wailing black prisoners mourning the death of a loved one.

That painting is one of the few remaining from the fifties and sixties, when Connell's old life was coming to an end and her new life in art was starting. Why it above all others was saved is unclear, but this modest work provides a bridge between where Connell had been and where she was going. Its subject points to the rich narrative experiences of her past, while the painting's somber gray tombstones protruding from the earth are omens of the gray, abstract, shaftlike sculpture that she would make in the future. Even then, it would seem, Connell felt compelled to give visual form to her life experiences, to find—to paraphrase the southern writer William Goyen—the speech that is hers by entering back into the worlds that bore her.

Entering into the worlds that bore her comes easily for Clyde Connell, for in most ways she has never left the world of her birth. More than three-quarters of a century later, her memory travels rapidly down the pathways of time to her childhood in the Old South, readily called to mind by the people and places still around her. The Red River runs through the saga of her life like the artery it once was to the cotton plantations along its banks. Instead of the glamorous lore of other southern rivers, the Red is better known as a cowboy's river, the dusty boundary between Texas and Oklahoma, than as a fellow traveler of the Mississippi or Sewanee. The hundred miles or so of the Red River that wander into northwestern Louisiana, once the extreme western edge of the Confederacy, seem to have slipped into the southern realm unannounced.

It was on the banks of the Red River running through cotton country in Caddo Parish, Louisiana, that Minnie Clyde Dixon was born September 19, 1901. She was born at the Woods Place, one of the five family plantations in the two northwestern Louisiana parishes where she would live her entire life. Her father, acting on an oath sworn one night with a group of cohorts, named his first-born

child after Scotland's great River Clyde. His baby girl would always be known by her male middle name, a name that would remain special to her father, Jim Dixon. Clyde was the only name of his nine children that he gave to one of his plantations, the Clyde Place.

The Dixon family was shaped by forceful personalities. Clyde's maternal grandparents, Dr. E. J. Hall and his strong-willed wife, Jane, were plantation people who had fled from Charleston, South Carolina, when the Civil War was brewing. They migrated to northwestern Louisiana in the 1850s, a corner of the largely French Catholic state that had been open to settling barely fifty years following the clearing of the Great Raft, the vast log jam that had obstructed the Red River for centuries. Shreveport, the Red River port named for the riverboat captain who cleared the waterway, was the commercial center of the region then as it is today. Once the river was opened, all manner of folk moved into the area, with the result that northwestern Louisiana had little of the French Catholic flavor of the southern part of the state. Instead, like the Halls and the Dixons, its residents were Protestants from the Celtic regions of Europe, making, in Clyde's word, all northwestern Louisiana "kin." Louisiana was deep in the Bible Belt by the time one reached Shreveport.

Clyde's parents were a study in contrasts. Her elegant mother, Hattie, had a keen and inquisitive mind, but her first duty was as a wife and manager of the lively Dixon household. She always called her husband "Mr. Dixon" in front of their children, never openly argued with him, and, though she was a proper member of the abstemious Belcher Presbyterian Church, "put up" with his drinking. She bore nine children but nevertheless led a relatively leisured life with the help of five or six black servants and frequent sojourns to the fashionable health spas in Hot Springs, Arkansas, often with a couple of children in tow.

Jim Dixon, seventeen years older than Hattie, was a fun-loving, clever man full

of colorful stories and mischief. He told his daughter that all Scots came to this country with decanters under their arms. On Sundays, after Hattie made the children recite Bible verses from heart, Jim would play poker with them in the storage room behind the kitchen. A shrewd businessman who successfully managed the family's five plantations, he was also keenly interested in politics and the development of northwestern Louisiana. It was Jim Dixon who persuaded the railroad from Texarkana to come through the farming community where his family lived, a community that eventually became the town of Belcher. Belcher, Louisiana, grew to five hundred souls, but, despite the efforts of the town fathers, it remained a sleepy plantation community.

In 1901, the year their granddaughter Minnie Clyde Dixon was born, the Halls moved into a splendid new white plantation house they had built in Belcher. After her husband's death in 1904, Clyde's grandmother sold the big house to her son-in-law, Jim Dixon, for one dollar. By 1915, it was an intergenerational household with thirteen family members, from infants to Grandmother Hall, living there. As the Dixon family grew, so did the sprawling white house, now known as the Dixon House. Jim Dixon built a second floor into the sloping roof, added two wings, and enclosed the dogtrot hallway. Later on, one of the large upstairs bedrooms became a ballroom for frequent neighborhood dances. Counting the servants who lived in the quarters behind the house, the place was always astir with life, an outpost of activity in the sparsely populated Red River bottomland.

Clyde Dixon lived in that house for forty-three years. Years later, when the idea of habitats and dwelling places entered her art, it would be shaped by memories of the cultivated ambience and stability she knew as a child living in the Dixon House. Her memories of it during her youth are richly nostalgic. Deep green magnolia, pecan, and oak trees surrounded it, and an exquisite flower garden tended by her Aunt Minnie bloomed

on the kitchen side. A dusty smell from the nearby cotton gin filled the air when the wind was right and swept through the high broad porches wrapping the house front and back. Inside, cherished memorabilia were scattered everywhere. Furnishings brought from South Carolina by the Halls were especially important in family lore: the old wooden sleigh bed, the long heavy rectangular dining table, the marble bookcases. In the entranceway was a picture of an elegant woman with a falcon on her hand, a painting made by Dixon's mother in New York in the late 1880s. The house seemed, in Clyde's memory, "to run by itself," ruled by an organic life of its own. Guests and family members came and went without a break in domestic routine. There was always enough food for one more plate at the table, always another bed for a visitor to stay overnight. Then the house would be filled with music, played at first by the black musicians who traveled by train from Texarkana to New Orleans, the capital of black music in the early twentieth century. Clyde recalls many a night in Belcher when the sounds of banjos and guitars, playing Stephen Foster tunes or Dixieland jazz, drifted over the cotton fields from the Dixon House or from the dance hall that Jim Dixon built over the nearby schoolhouse. "People would come to our house and stay from all up and down the river for dances. We had Negro bands in those days. They'd play ragtime and waltzes and everybody would dance. My grandmother was a great dancer. She had learned in South Carolina."

The Dixon household was a cultured one. When the family was not entertaining, its members amused themselves primarily, in those preradio days, through reading and conversation. Both parents encouraged their children to order books from the publishers' catalogs that came to the house from New York. Unlike her sister Jean, who always asked for fairy tales, Clyde almost always ordered books of poetry, particularly by romantic nineteenth-century English poets like Robert Browning, Alfred Lord Tennyson, Wil-

liam Wordsworth, and Rudyard Kipling. To these she added the American transcendentalists Walt Whitman and Ralph Waldo Emerson. Deeply immersed in a near-mystical fascination with nature, these nineteenth-century writers made a profound impression on the young Clyde. The family also ordered fine arts prints from the publishers, typically reproductions of nineteenth-century English and French paintings.

As a politics and history buff, Mr. Dixon directed the nightly dinner table conversation toward world affairs and contemporary social issues. He expected all nine of his children to participate in these discussions, laying the groundwork for Clyde's life-long interest in history and world events. The discussions also planted the seeds for her youthful questioning about the status quo in genteel Louisiana, particularly regarding sex and race. "I remember listening to my aunt, my mother, and my grandmother sitting on the porch day after day talking among themselves about all the people of Belcher. I distinctly remember one day saying to myself, 'I'm not going to talk about people when I get older. I'm going to talk about ideas.'" However, to keep peace in the family, Clyde learned to keep her questions to herself. Painfully shy as a girl, she began to develop private opinions about life that differed notably from prevailing notions. "I decided when I was growing up that it was a sin to think. I must have asked an awful lot of questions because I remember the adults around me saying, 'You can't worry about that.' I learned not to ask questions, but I kept thinking. I learned to put two and two together, to find out things for myself. After awhile, it didn't seem to matter so much anymore because I had made up my mind to continue to inquire."

From her earliest memory, Clyde was bothered by the social distinctions made between blacks and whites. The black people around her were the "doers," the often-skilled workers who tended the fields and made the quilts. Effortless as it seemed, plantation life ran smoothly only because all the housework was done by black servants, sometimes children of former slaves who had come to Louisiana with the Halls. During Clyde's childhood, no fewer than five full-time servants worked for the Dixons. They included the cook and his helper, Babe the washerwoman, at least one nurse to tend the children, and a yardman. On laundry day once a week, Clyde and her sisters would throw their white linen dresses out the second-story window—they called it their "laundry chute"—to Babe the washerwoman, who would hand wash and iron the garments. The drudgery of childcare was almost entirely the responsibility of blacks.

On the one hand, Clyde recalls the tales told by her South Carolina grandmother about the horrors of Reconstruction and the threats of angry blacks. On the other, there was her nurse, Susan, a former slave who had come from Carolina and to whom even Jane would defer. "My first remembrance was trying to think things through and wondering why the white and the Negro couldn't get together. You see, I had a Negro nurse named Susan and she was the one who had come from Carolina with my grandmother. I thought as much of her as I did the family. She was the Big Person. She would sing and dance and there was never any doubt where Susan stood. Even my grandmother would say, 'Go ask Susan,' because she was the big one in the house."

Clyde remembers with particular horror the lynchings that occasionally occurred in Belcher. Lying in bed one night, she heard the sound of horses' hooves pounding across the wooden bridge. Outside her room, her mother and grandmother were whispering that the vigilantes were off to catch a black. On another terrifying occasion, unknown to their parents, the children had witnessed the capture of a black man in the servants' quarters behind the house. "The posse had gone to catch the Negro and we saw him. He had been running and his eyes were popping out. He was lying on the porch of the servants' quarters with ropes on. We all were

scared and I was fearful for him." After one of these times, when Clyde was only two or three years old, her nurse took her for a walk. Mourning for the ill-fated black man, as she walked holding Clyde's tiny hand, Susan wailed a deep sorrowful sound that Clyde eventually associated with the sound of elemental life. "A Negro had killed a white man and a posse had killed the Negro. Susan was moaning as we walked. I can't even remember her face, but I remember those sounds and her mourning. I knew she was sad by her singing and chanting. Those sounds are where I want my art to come from."

During her childhood, Clyde demonstrated no extraordinary interest in art, although, even then, the house motif was a popular one for her. Her favorite play place was an imaginary house created by a bend in a tree at the mouth of an underground spring. She spent hours tending her "house," sweeping clean its mossy floor, arranging rocks for pathways, settling into "furniture" where she could read her beloved poetry. Indoors, she made shadow-box houses from the boxes for her mother's huge fancy hats. Cutting windows and doors into them, she propped figures cut out from mail-order catalogs as the characters for her tiny stage sets. Inside, a candle cast a yellow glow from the doors and the window openings. Her imagination ran free in these miniature environmental sculptures of rooms, parks, and city scenes.

The education she received in the one-room Belcher schoolhouse was likewise unexceptional, designed like most female education at the time to provide only the minimum skills needed to become a plantation wife and mother: music, art, and literature. Even so, she was more fortunate than most southern females for, at the time Clyde graduated from Belcher High School in 1919, only 20 percent of southern women ever graduated from high school.* After high school, she and her sister Jean were sent to a girls' finishing

school outside Atlanta, Georgia. Brenau College, founded in 1876 as the Georgia Female Baptist Conservatory, promised to provide the proper religious orientation for southern ladies as well as polish their feminine graces. At Brenau, Clyde was given her first academic introduction to art: watercolor and drawing from plaster casts instead of live models. She preferred charcoal drawing most of all, once dropping a sculpture course to return to drawing.

Art and spirituality, linked so explicitly in the proper nineteenth-century education of a young southern woman, would cross paths many times as Clyde's artistic identity developed. Reared in a region that remained virtually unchanged from antebellum days, Clyde was taught, as her mother had been, that high-minded women should be nurturing protectors of culture, not producers of it. Their domain was the home, idealized as an island of calm in the storm of life and at times even supplanting the church as a spiritual refuge.* This near-mystical cast on the southern home is reflected in Connell's later work when the "habitat," defined as the place where an organism lives and grows, is expressed as a religious sanctuary.

Hattie Dixon chose to send her daughters to Brenau College because of its religious orientation but, when she found its churchly instruction lacking, Mrs. Dixon whisked the girls to Vanderbilt University in Nashville, Tennessee, where family friends could watch over them. Clyde, unprepared for the academic demands of one of the South's finest universities, foundered there and returned home to Belcher after one year. In 1922, she embarked on the only occupation she had been prepared to pursue by marrying T. D. ("Thomas Dixon") Connell, the son of a successful local planter whom she met after returning from Vanderbilt. Two weeks after her marriage, Clyde's father accidentally shot and killed himself. Jim

*Virginius Dabney, *Liberalism in the South*, p. 370.

*Donald G. Mathews, *Religion in the Old South*, p. 100.

19

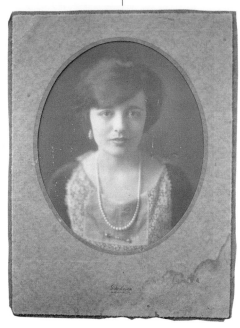

Clyde Connell,
1922

Dixon, then in his sixties, was in his office at the Dixon home cleaning his gun when it fired. Hattie found her husband, a gentleman until the end, slumped over his desk wearing a crisply starched white shirt. Overcome by his death and with eight children still at home, the youngest being six, Hattie collapsed. She recuperated for a month at Hot Springs while at home history was repeating itself.

Within a month after their wedding, newlyweds Clyde and T. D. Connell had moved into Dixon House, starting where her parents had left off. T. D. took up the business of running the Dixon plantations just as Jim Dixon had stepped in at the death of his own father-in-law. And, like her grandmother, who had died four years earlier, Clyde, then barely twenty-two years old, began managing the house while her mother recuperated. An era had ended and another had begun, but the house stayed the same. The house, at least, seemed to run by itself.

Shreveport, Louisiana, in the 1920s was a conservative community more interested than most in maintaining the social order of the Old South. Even Huey P. Long, the progressive governor of the state who had practiced in Shreveport as a young lawyer, was routinely snubbed in the city, less because of his liberal political views than his lack of plantation status. "I would never have liked him re-gardless of his ideas," said one resident of the time. "I would never have asked him to my house. He didn't associate with the nice people."*

Clyde Connell associated with only the "nice" people of Belcher in her early married life. With her life revolving around home, family, friends, and church, she put to good use her training to become the proper southern plantation wife and mother. She and T. D. lived in the big Dixon House almost continuously from 1922 to 1949 and raised three children there—a daughter, also named Clyde, and two sons, Dixon and Bryan. Yet, in the small town of Belcher, her friendships were often determined by class distinctions. "If you didn't get into a crowd to run with," she recalls, "you'd never have a group. Whites didn't integrate with different classes of whites." Her social acquaintances were drawn almost entirely from members of other plantation families in Belcher or nearby Gillam or Dixie. By the mid-1920s, she was restless. "I knew this life was not for me," she recalls. "In those days, women were expected to stay at home and play bridge and socialize a lot. I really wanted to go to art school."

Clyde enrolled in art classes in Shreveport in the mid-1920s, driving into town twice a week to study at St. Vincent's

*T. Harry Williams, *Huey P. Long,* p. 97.

20

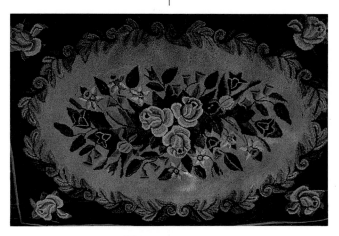

HOOKED RUG, 1929
Dyed wool, 8 × 4 feet
Private collection, Allentown, Pennsylvania

Academy, a girls' school that offered the town's most serious art courses. There, the conventional nineteenth-century academic art training she had received at Brenau continued: draftsmanship, watercoloring, still lifes. Floral subjects were the most popular, particularly magnolia blossoms, which, Clyde wryly comments, were required subjects for any self-respecting southern artist. For five years in the 1920s, she studied with a fashionable Shreveport woman artist named George Doaks, who specialized in impressionistic landscapes and still lifes. Doaks apparently did not make stylistic impositions on her students, however, and Clyde recalls that she was given free reign in those classes about style and subject matter. By the late twenties, Clyde Connell was an accepted member of Shreveport's small serious art community. One of the earliest, and unlikeliest, applications of her art training came humbly enough through a local ladies' activity—rug hooking. Despite her genteel upbringing and her parents' total lack of involvement in handiwork of any kind, Clyde became unexpectedly adept at this supposedly domestic art. Unlike her friends for whom rug hooking was primarily an excuse for socializing, Clyde ended up teaching herself from books how to make silkscreen patterns for her original designs, typically floral subjects or simple patterns, and

learning how to dye scraps of wool into exact colors. Eventually she abandoned patterns altogether, creating freehand designs as the rug progressed. Altogether, she made twenty-five hooked rugs, the largest measuring nine by twelve feet.

Like the women's quilting bees of an earlier era, the weekly rug-hooking meetings also functioned as informal discussion groups in which a range of topics from local gossip to politics were covered. Around 1925, Clyde was enlisted by one of the more progressive members of the group, Ruth Yarborough, to teach Sunday School at the Belcher Presbyterian Church. Yarborough drafted her again in the early 1930s, this time to teach Vacation Bible School one summer in Belcher's black Presbyterian church. Teaching in the local black church not only was Clyde's first step toward a life of social consciousness but also provided entree to the field of religious education at a time of dynamic change in Protestant theology. Initially, however, Clyde was simply drawn to the emotional power of the black religious experience, particularly its music and to some extent its liturgy. As it was practiced in Belcher's black Presbyterian church before World War II, "old-time religion" showed signs of its ancestry in African spiritualism brought to the South a century earlier by the slaves. A central metaphor of this spiritual sys-

tem was the one of life's journey through a difficult earthly existence with the righteous ultimately rewarded by passing into heaven and a life of harmony. This liturgical point was most effectively illustrated through the haunting rhythms and evocative words of the black spirituals. Clyde found working in black churches appealing because she found the music there "so fantastic." When the white teachers were once asked by the black parishioners to sing a song, she recalled, the teachers would have preferred singing a spiritual but, she concluded, "that wouldn't have been right. So, we sang, 'Jesus Loves Me, This I Know.' It was a simple song but, when we were through, they laughed and laughed because their music was so gorgeous and ours was so bad."

Connell's willingness to cross the color barrier to teach in black churches reflected her native independence and humanitarianism as well as theological changes taking place in American Protestantism. The Presbyterian church, along with other denominations around the country, began a period of reform during the 1930s, particularly in its educational programs, which culminated two decades later into what was called a "theological renaissance" in the United States.* This reform can perhaps best be characterized by the philosophy of Paul Tillich, the Protestant theologian expelled from Nazi Germany who came to this country in 1933 to teach at the Presbyterian-founded Union Theological Seminary in New York. Not only did Tillich advocate a new cultural theology directed toward the realities of modern life, including its politics and social conditions, but he also presented provocative new applications of aesthetic experience as ways to achieve ontological knowledge, which he equated with spirituality.

As Tillich's broad-based ideas began to enter Christian literature, Connell was exposed to them both directly and indirectly

*J. Edward Dirks, "About the Journal," *Christian Scholar* 36, no. 1 (March 1953): 3.

because, during the 1930s and 1940s, she was deeply involved with religious education training. As a result of that first teaching experience in Belcher's black Presbyterian church, she entered the progressive Leadership Training Program sponsored by the Presbyterian denomination for its Sunday School teachers. Connell attended more than sixty workshops over the years, many of them dealing with the psychology of creativity and the development of individual identity. Among the forward-thinking writers with whose work she became acquainted during these years were, in addition to Tillich, philosopher John Dewey, particularly his *Democracy and Education* and *Art and Society;* Indian poet-philosopher Rabindranath Tagore; Lewis Joseph Sherrill, dean of the Louisville Presbyterian Seminary; and Elizabeth McEwen Shields, director of the Children's Division of the Department of Religious Education of the Southern Presbyterian Church.

Connell, whose own three children were then still youngsters, specialized in kindergarten teaching, adding her own emphasis on art. The church curriculum that she doubtlessly followed was one written in 1931 by Elizabeth Shields, *Guiding Kindergarten Children in the Church School,* as part of the Standard Leadership Curriculum for the Presbyterian church. Miss Shields, who also edited two songbooks for children, placed great emphasis on the importance of music for preschool education, then a rather advanced idea in aesthetic education that may initially have piqued Connell's appreciation of the spiritual nature of sound. In a section subtitled "God Speaks through the Music of Nature," Miss Shields writes that "primitive man learned to listen to the rhythmic sighing of the wind in the trees; the cadence of the waterfall; the harmony of the wavebeat on the shore; and the melody of the bird song. . . . When we quietly let nature sing to us, we do not wonder that music has been linked with religion," she continues, concluding that "music is the language of the emo-

tions."* While European intellectuals of romantic persuasion had long mused about the perceptual make-up of primitive people, this reference to primitivism in a Sunday School curriculum to be taught in Belcher, Louisiana, may have been one of the first instances in which Connell could put to use these ideas in her everyday life.

By 1952, after nearly twenty years of church involvement and with her children now grown, Connell was ready to assume the church leadership role for which she had been so well trained. Elected president of the Presbyterian Women of Louisiana, she thus automatically became a member of the Board of Women's Work of the Presbyterian Church in the United States. From there, she was elected as a southern representative to the National Council of the Churches of Christ in the United States of America, the newly formed progressive ecumenical body based in New York. She was appointed to the Home Missions Committee, whose responsibility it was to evaluate religious materials about domestic missionary efforts trying to reach marginal social groups in the United States. One of the committee's major tasks was developing text material related to migrant workers in this country, a project with which Connell was involved during her tenure on the committee from 1954 to 1962. For her committee work, she was required to attend meetings every six months, trips that also introduced her to the New York art scene.

Connell's work on the Home Missions Committee constituted the final "modernization" of this once southern belle. Throughout her years of volunteer work in progressive religion, Connell's independence as a woman and her humanitarian outlook toward southern blacks had not set well in conservative Belcher. As she described it, she was a "thorn in the side" of both her plantation-class friends and her own family. Belcher folk

*Elizabeth McEwen Shields, *Guiding Kindergarten Children in the Church School*, p. 154.

were known to refer to her as a "radical" and, during the 1950s when she was at the peak of her involvement with liberal religion, one of her own family members called her a Communist because of her liberal outlook. Connell was not just another armchair liberal; because of the role played by the National Council of Churches in the civil rights movement in the 1960s, she had personal contact with the struggle for integration in the South. She recalls teaching a class in a black Presbyterian church in Birmingham, Alabama, when Ku Klux Klan night riders circled the church, throwing stones and threatening its occupants. Connell is matter of fact about the courage it required to withstand both physical danger and the acrimony of her family, and it apparently never occurred to her to change her course or modify her position to appease public opinion. As she says, it was just something she "had to do." "Integration was a very serious thing. For me, it didn't take courage, it was just a matter of course. After all those years, I believed we should have integration. I got lots of comments which weren't exactly threats about how I was doing things I shouldn't be doing, stirring up things. The hard part was trying to make them understand what you were trying to do. I wasn't being inflammatory or trying to start riots. I was trying to teach people to live together." Such convictions would not be forgotten later when Connell turned to art.

Back in Belcher, life on the plantation had become increasingly difficult. Southern life was changed forever during the Depression and the years prior to World War II. The Connell family suffered economically during these years. With twenty-five tenant families working on the Connell farms, T. D. struggled to stay afloat, but, in the end, he lost nearly all the family landholdings to foreclosures. All that was left was the old Dixon House and the five acres it was on. For the only time in her life, Connell took a job. For six months in the mid-1940s during World War II, she was program director for the

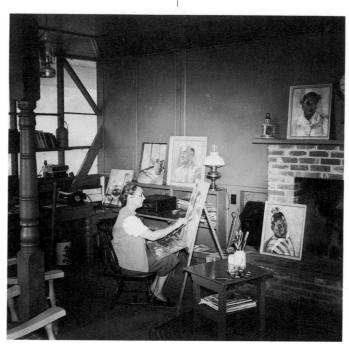

Studio at Caddo Parish Penal Farm, 1956

Shreveport YMCA, working with soldiers on leave from nearby Barksdale Air Force Base. All the old ways were gradually melting away.

The Old South was still alive, however, at the Caddo Parish Penal Farm some twelve miles southwest of Shreveport in Greenwood, Louisiana. This 1,000-acre minimum security prison farm ran on much the same order as the plantations of yesteryear. Fields of cotton, now only partially handpicked, were tended by primarily black inmates. The relationship between the farm superintendent and the prison inmates was reminiscent of the one between the plantation master and the slaves. When the penal farm superintendent suddenly died, Connell encouraged her husband to apply for the job. Though T. D. had never worked for anyone, he had always managed his own farms. As a member of the parish police jury, he was well known and respected. In 1949, when he was named the new penal farm superintendent, the couple moved to Greenwood, leaving Belcher forever.

The move to the Caddo Parish Penal Farm was a successful one for the Connell family. At the age of forty-eight, Connell was a vigorous middle-aged woman with what promised to be her most productive years ahead. Her three children had finished college or were on their own. Daughter Clyde had graduated from Louisiana Tech, soon to marry and move near Philadelphia in the early 1960s. Dixon had returned from World War II and was studying botany at Louisiana State University in Baton Rouge on the GI Bill. Bryan, the youngest, had graduated from LSU and was coaching high school football before becoming a Belcher cotton farmer. The regular income from the penal farm removed most of the economic worry that had grown chronic in Belcher. The superintendent's house was staffed by inmates as servants, giving Clyde once again the independence she had always known. With her involvement in liberal religion at a peak in the 1950s, the decade would be a watershed period in her life, ushering in art as a major new preoccupation.

Progressive Vistas, 1949–1975

What conditions are necessary for the creation of works of art? So asked Virginia Woolf, musing about the paucity of women writers in the history of literature. Bound by the demands of domesticity, women would nevertheless be as numerous as men in literature, she reasoned, if they could find two keys: fixed incomes and rooms of their own.

Connell was almost fifty when she moved into her first permanent studio. During all the years she lived in the big Dixon House, she had never had a room that was hers alone. Like Woolf's women authors trying to write in the midst of busy sitting rooms, Connell had tried for years to paint amid the bustle of her growing family. Her work area had moved from bedroom to bedroom, routinely usurped by household demands and constantly interrupted by children, husband, and an aging mother. At the Caddo Parish Penal Farm, Connell was finally freed from demanding family responsibilities. But, best of all, a small separate building that had once been the farm's dairy lay empty and unused near the superintendent's house. With its tall metal windows and concrete floor, it made a perfect studio.

Moving into the new studio in 1949 meant more than improved working conditions for Connell's art making. Leaving Belcher and the Dixon House where she had been born began a period of personal and professional reassessment, coinciding almost precisely with her work with the National Council of Churches and her regular trips to New York. Stimulated by the advanced social thought discussed at the council meetings, she also witnessed in New York the start of a new era in American art: the birth of abstract expressionism. Never before as in the art galleries and museums of New York had Connell been so exposed to abstract art. Drawn to its color and form, she was fascinated by the ability of abstract form to provoke intellectual inquiry in a visual realm previously unknown to her. "I thought abstract art was fantastic," she says. "It was discovery for me of new ways of doing and seeing. It took some real thinking to get meaning and feeling out of abstraction."

It was not long before Connell anticipated her New York trips more for the art she would see than for the church meetings she would attend. For months before each trip, Connell pored over art publications until her head was swimming. Waiting one late night in a Virginia railroad station to catch the next train to New York after attending a training workshop, she remembers watching gusts of newspapers on the track being tossed into the air by wheels of whizzing black locomotives. "It reminded me of what I had read about Franz Kline paintings in the magazines about the thrust of his strong black lines. I thought to myself 'Soon, I'll see the real thing.'" Guided by a sketchy gallery list made for her by an enlisted man at the Barksdale Air Force Base, Connell found her way through the New York galleries and museums, absorbing the excitement of abstract expressionism. She remembers her trips to the Stable Gallery, which gave many abstract expressionists their starts, and the Museum of Modern Art, where, she claims, she received her education in modern art.

The artistic milieu in postwar New York was most exciting, however, because American art was in transition, the dogma of formalist modernism not yet ossified and its heritage in a human-centered aesthetic still very apparent. A traditional American predilection for locating symbolic meaning within nature, first reflected by the synesthetic abstractions of 1920s artists like Arthur Dove and Georgia O'Keeffe, had merged in New York after World War II with movements developed earlier in Europe, surrealism in France and expressionism in Germany. Both European movements embraced primitive art from Africa and Oceania because such work was believed to be a pure expression of the human unconscious, unsullied by rigid regulations of modern civilization and unaffected by the psychological trauma of war.

The New York art world of the 1950s, in addition to touting the new American

abstract expressionism, equally reflected other developments in modern art. Two exhibitions at the Museum of Modern Art, which Connell doubtlessly saw because she never missed a show there in the 1950s, presented striking philosophical parallels to the religious ideas to which she was also then exposed. New Images of Man, an international show organized by Peter Selz at the Museum of Modern Art in 1958, cut across geographical lines to include works by leading New York abstract expressionists Jackson Pollock and Willem DeKooning, Leon Golub and H. C. Westerman from Chicago, and West Coast artists Nathan Oliveira and Richard Diebenkorn as well as European artists Jean Dubuffet and Francis Bacon. Sculpture in the show by Alberto Giacometti, Kenneth Armitage, Cesar, and Paolozzi bears the same rough organic quality that eventually would characterize Connell's sculpture. Writing the catalogue preface was philosopher Paul Tillich, who explained the works in this show in terms of cultural theology and the efforts of these artists to resist "indifference to the question of the meaning of human existence." Calling them "representatives of protest," he wrote that "humanity is not something man simply has. He must fight for it anew in every generation, and he may lose his fight. There have been few periods in history in which a catastrophic defeat was more threatening than in ours. One need only look at the dehumanizing structure of the totalitarian systems in one half of the world, and the dehumanizing consequences of technical mass civilization in the other half . . . [These artists] show the smallness of man and his deep involvement in the vast masses of inorganic matter out of which he tries to emerge with toil and pain. . . . They reveal the hidden presence of animal trends in the unconscious and the primitive mass-man from which man comes and to which civilized mass-man may return." *

In 1959, the sculptor Frederick Kies-

ler, who Connell has claimed as an important influence, also showed his masterwork *The Endless House* at the Museum of Modern Art. Kiesler was an artist deeply influenced by primitive art and surrealism whose 1947 sculpture *Totem for All Religions* attempted to present an ecumenical symbol for the world's religions. His *The Endless House* was a huge organic structure that he called a "man-built cosmos" where "the congregations of real people as well as those of the imagination will live together peacefully in an endless house," a place where "the events of life are your houseguests." * Such sentiments were echoed years later by Connell when she built her "Habitat" sculptures.

However, it was not sculpture but the abstract paintings of Adolph Gottlieb, one of the original abstract expressionists, that made the most immediate impact on Connell's work. Already attuned to the harmony between sound and nature, Connell was particularly drawn to Gottlieb's cross-perceptual, or synesthesia, paintings from the late 1940s and early 1950s, such as *Sounds at Night* (1948) and *The Frozen Sounds* (1952), which she saw in New York in the early 1950s. Gottlieb had undergone a period of deep introspection and doubt in 1939–40 during the escalation of World War II. "There was some sense of crisis," he wrote, "I felt I had to dig into myself, find out what it was I wanted to express." † Fully comfortable with neither cubist abstraction nor surrealism, he turned to the primitive pictographs of the Southwest Indians as a way to present subjective content on a flat picture plane. Usually gridded into compartments filled with notations, Gottlieb's pictographs drew from diverse artistic sources as well as psychological theory in his effort to wed abstraction and surrealism into a new form.

While Connell was fascinated by abstraction during the early 1950s, she did not immediately adopt an abstract style

*Paul Tillich, quoted in *New Images of Man*, by Peter Selz, pp. 9–10.

*Frederick Kiesler, *Inside the Endless House*, p. 567.
† *Adolph Gottlieb: A Retrospective*, p. 29.

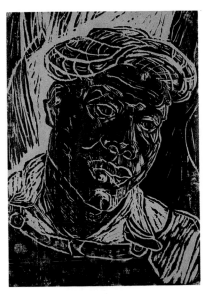

CIRCUMSTANCES, *1956*
Woodcut, 13½ × 9½ inches
Private collection, Allentown, Pennsylvania

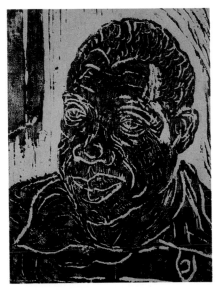

ROBERT, *1956*
Woodcut, 13½ × 9½ inches
Private collection, Allentown, Pennsylvania

but began making expressionistic portraits of the black prisoners at the Caddo Parish Penal Farm. Vaguely social realist in orientation, these woodcuts reflected her growing concern with the social conditions in the South. At the same time, because the prison farm with its black servants and inmates was a reminder of her earlier life on the plantation, these works allowed her to establish a personal psychological connection between her art and her life through both materials and subject matter.* Using weathered pieces of wood—old farm fenceposts, lumber from crumbled buildings—to carve her woodblocks, Connell first discovered the aesthetic potential of "found," not just

*While today often considered a reactionary artistic philosophy, regionalism and its main proponent Grant Wood were once considered progressive in their emphasis on personal experience as central to meaningful expression. As Wood explained, "Each section has a personality of its own, in physiography, industry, psychology. Thinking painters and writers who have passed their formative years in these regions will, by care-taking analysis, work out and interpret in their productions these varying personalities" (quoted in *Grant Wood: The Regionalist Vision,* by Wanda Corn, p. 43).

new, materials in her art. The wood was an earthy, organic material used and weathered in her own native environment, the rural Louisiana landscape, making this material the first instance of a formal link between the locale of the artist's birth and her work. Though not yet used sculpturally, the wood also allowed Connell to work more physically and tactilely than in the more delicate media of painting or drawing. She recalls the unworkmanly first materials she used to make her woodcuts: "three different length screwdrivers and a hammer."

During the penal farm years, Connell made the small oil painting of black inmates wailing above a graveyard. This expressionistic work, her first to deal directly with death, is based on her memory of a prison scene in which the death of an inmate's mother was being mourned. The painting explicitly refers to a burial ground and the Afro-American concept of the afterlife, introducing several important themes for her later work. The tall, columnar, gray gravestones would reappear as tall stonelike totemic sculpture. The religious context of the scene, indicated overtly by headstone crosses, would re-emerge as abstracted interpretations of

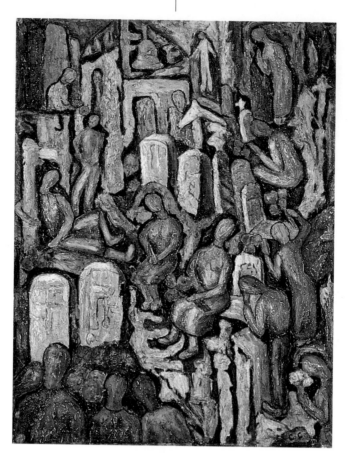

MEMORIAL, 1955
Glazed oil on fiberboard, 23 × 18 inches
Collection of the artist

LATE VERTICAL SERIES, 1969
Collage on fiberboard, 11½ × 11¾ inches
Collection of the artist

BELCHER STATION, 1954
Woodcut, 11½ × 33½ inches
Private collection, Shreveport, Louisiana

the otherworldly. The idea of bodily passage from the earth to a higher state, a central aspect of her mature work, is explicitly stated in theistic terms by a sweeping white God-like figure at the rear of the graveyard, supposedly carrying the dead mother's spirit to heaven.

An incident occurred during these years that marks the beginnings of Connell's association of sound, primal human existence, and her art. Stopping for gas one day, she was "as usual" thinking about art when, out of the blue, the sorrowful wailing sounds once made by her black nursemaid, Susan, came to mind. Connell immediately recognized in the sounds the elements she wanted for her art. "They were deep guttural sounds, containing everything I'd been feeling. These sounds contained a certain quality—they were deep, sincere, honest, and right. Something in those sounds was what I wanted to paint. I associated them with living and being. Just being. Because to me, when Susan was making those sounds, she was at her deepest being." This association between sound and the human condition may have been conditioned by the relationship between music and the "voice of God" discussed by Elizabeth Shields to religious education workshops that Connell attended. It also bears uncanny resemblance to the "inner sound" identified in 1912 by the German expressionist painter Wassily Kandinsky in his book *The Problem of Form.* Author of the semi-

nal book *Concerning the Spiritual in Art,* Kandinsky wrote in an earlier work that it was in the inner sound of objects that the artist finds "the spiritually expressive" core of reality that "rings out" and points the artist in the "right direction."* The memory of Susan's mourning clearly led Connell in the right direction.

Perhaps more certain now of her aesthetic goals, Connell began venturing into abstraction of a purely formal nature. Her first abstract paintings, called the "Vertical Series," were straightforward experimentations with nonrealistic imagery reflecting a melange of influences from Hans Hoffman to Clyfford Still. Based on an irregular pattern of vertical bars, the bright, thickly painted works, nevertheless, even then had a sturdy sense of sureness in the resolution of contrasting color with form. Connell appears less accomplished as a colorist in these early paintings than as an artist with an intuitive sense of form and space, even on this two-dimensional plane. She had not yet tried her hand at sculpture but her preoccupation with shape and texture could already be seen.

As her interest in abstraction grew, nudged along by her trips to New York, Connell became increasingly restless with the artistic conservatism of Shreveport. In carrying the gospel of abstraction back

*Wassily Kandinsky, in *Voices of German Expressionism,* ed. Victor H. Miesel, p. 60.

home to Shreveport, Connell had met with stiff resistance from the local cultural community. Recalling that the city was then "about fifty years behind the art world," Connell says artists there were still "copying realism." People disapproved of abstraction with a moral fervor that baffled Connell. "They thought it was subversive and was meant to confuse and confound people. Everybody kept saying abstraction would disappear and then the American way would return. People dedicated their lives to seeing that the American ways prevailed."

Using her organizational background, in 1954 Connell helped form the Shreveport Contemporary Art Group. The group, composed of a handful of progressive local artists, had a controversial beginning. In the early fifties, the only exhibition space in Shreveport was the State Exhibit Museum on the fairgrounds of the Louisiana State Fair, where the Shreveport Art Club met every Monday night. With two friends, Connell proposed that the Shreveport Art Club stage the city's first exhibition of abstract art by area artists at the State Exhibit Museum, then noted for its diorama displays. Dr. B. M. Wright, the museum director responsible for the diorama exhibits, approved the proposal, but when he walked into the exhibition in the fall of 1955, according to Connell, he looked as though he was "going to have apoplexy." After the opening, in horror, Wright nervously had the show removed only to have the group reinstall it the next day. Finally, the director placed a huge sign outside the show. It read "Louisiana State Exhibit Museum is in no way responsible for this show," but the show remained. As the abstract artists' group gained credibility in the city, its membership grew to eight Shreveport-area artists. Requests for exhibitions by these progressive artists started to come in from regional art centers, and, in that first year, the group had shows in the Louisiana Art Commission Galleries in Baton Rouge, Central Louisiana Galleries in Alexandria, and a gallery in Fort Smith, Arkansas.

Connell seemed poised to begin her role as one of Shreveport's leading artists when the freedom she had found at the penal farm came to an abrupt end. Barely ten years after the move to the penal farm in 1949, T. D. suddenly lost his job as superintendent two years before the couple had planned a comfortable retirement. The news came as a blow to Clyde. Now required to leave the farm, they moved into their cabin on Lake Bistineau, a recreational lake seventeen miles southeast of Shreveport. After two years there, they moved to a smaller lake cabin designed by Clyde. T. D. took up work as a real estate agent, selling lake property, and Clyde began to pick up the pieces of her life. Just as her grandmother had nearly a century before, Connell, at age fifty-eight, began rebuilding from scratch.

The first three years she lived at Lake Bistineau are a blur in Connell's memory, the pain still fresh after nearly thirty years. She remembers the confusion of having to adjust to new ways of living in this primitive, remote place. What she remembers most was the isolation, the physical and emotional estrangement from everything she had always known. Living for the first time without a car at her disposal, she was cut off from both her artist friends and her church work. Then, there was the change to a life of relative poverty. By comparison with what she had always known, life was stark at Lake Bistineau. Without servants for the first time, Connell learned to cook simple meals for her husband and herself. Managing a household from top to bottom was also new for Connell as she set about rebuilding a life from the rubble of the construction of the new concrete-block house. First the larger concrete-block fishing camp and then the smaller one were radical departures from the rambling comfortable Dixon House and even the spacious home of the penal farm superintendent. The cabinlike house was simple and efficient, but it had no storage space for the boxes of keepsakes accumulated by the Connells over the years. As a result, in a kind of purging of her earlier life, Connell

threw out most of her files related to her church work and early art involvement.

Slowly, the restorative powers of Lake Bistineau began to work. People had been coming to Bistineau for years from Shreveport to unwind and relax, to escape the hustle of modern life. Though the land was rich, the area was remote, inhabited by a few farming towns linked by only dirt or gravel roads. The French gave Lake Bistineau its name, but it was the Caddo Indians who were first aware of its magic. Created by a natural dam that flooded Bayou Dorcheat to the north, the lake engulfed large stands of tall spikelike cypress trees. Silvery webs of Spanish moss hung heavily from the gray trees, occasionally scattering mossy flowerlets on the still, glassy water. These patches of moss droppings, which looked like drifting islands of bubbles, caused the Indians to call the lake "frothy water." The lake was churning with life: it could be heard in the constant drone of the bullfrogs and insects and seen in the ripples of fish feeding on insects that ventured too close to the water's surface.

At Lake Bistineau, Connell entered an intense and often painful period of introspection buoyed by the ontological questioning she had learned during her religious training. "I don't remember so much all the horror of it as trying to understand what it is to *be*," she recalled. "I was in the process of thinking things through, trying to accept the way everything had happened so that I could rebuild . . . I was working myself out of a void." To sort through this existential dilemma, she immersed herself in the creative process through which she found a way to both transcend the particularities of her life and to build hope for a new life. After three decades of working with the southern black church, Connell openly identified with the human struggle of the blacks. Finally free from the restraints of the plantation river culture, she turned to more universal issues of identity, which included awareness of the social complexities of southern life. When she began examining her own life, primitive imagery

entered her work. "I had always wanted to produce *good* art and now I wanted to produce something I myself wanted to do. I had been greatly influenced by New York art, but here I was in this position. William Faulkner began to mean a great deal to me at that time because I think his life was spent in thought and his own experiences. His art came out of his life."

Every aspect of her own life in the early 1960s, during those years of isolation, became oriented to art. Instead of restricting herself to a one-room studio, she now took over the entire house. What was originally a living room became the main studio, to which three broad screen porches were attached. Later, two of the porches were enclosed and the main work space moved there. The kitchen area shifted somewhat and T. D.'s bedroom remained the same, but the rest of the house moved as organically as Connell's future sculpture. The main studio, where Connell slept on a cot, eventually settled on the screen porch, insulated with sheets of clear plastic, which faced onto the broad front yard. As her work space, the studio became the activity center of the house. On summer evenings, when T. D. was not working, fishing, or visiting with friends at the corner store, he joined his wife in the studio, air conditioned to stave off the blistering Louisiana heat, to watch television on a small black-and-white set. The rest of the house facing onto the pier into Lake Bistineau became a gallery of Connell's work. The cypress lumber she would later use for sculpture was stored in sheds off to the side of the house.

During this period, Connell began developing artistic themes that corresponded with her beliefs about human progress. Drawing from both her past and the advanced art ideas she now had ample time to digest from reading contemporary art journals, she placed at the center of her aesthetic the redemptive power of nature. In this view of life, she invested nature with a kind of moral force characteristic of the pastoral nineteenth-century view of nature, which she had legitimately inher-

ited from conversative Louisiana culture. As a sign of her artistic progressiveness, Connell had formerly rejected the flora and fauna subjects locally popular in art—for instance, she never made a painting of a landscape in those early years—but she was now open to including her natural environment in her work just as William Faulkner had turned to his natural "habitat," the South, for subject matter. Indeed, Connell began to view all things, including art and human life, as part of a natural order. "I began to think about people as being part of nature, part of an overall scheme of things," she said. "I began to think that about everything, including my art."

Natural order, a centuries-old philosophical subject, was once again being explored during the sixties and seventies by vanguard artists. Minimalism and conceptualism, two contemporary art movements that appealed enormously to Connell, hoped to apply a rational, almost constructivist interpretation to the understanding of nature defined by these movements as more intellectual than romantic. Connell liked this "look of thought," particularly in the sculptural work of Sol LeWitt, because it conformed to both the rigorous intellectualism she wanted for her art and her respect for simple, well-constructed form. It was through such simplicity that she believed a higher, more egalitarian state of consciousness could be achieved. "I like that cool intellectual approach. I like the cool intellectual approach to organization, too. I'm not much for spontaneity. If you've got time to add things, you can. I like order, but not too much of it."

Attracted though she had been to geometry since her first forays into abstraction with the Vertical Series paintings, Connell would not embrace severe geometry in her sculpture until much later in her life, and even then with qualifications. Instead, beginning in the mid-1960s, she used geometric forms as mystical symbols to illustrate her philosophical viewpoint. Many ancient and primitive cultures had used geometric shapes for mystical pur-

poses and, during the era of abstract expressionism, artists had actively borrowed them from primitive art. Connell had no doubt seen, either in reproductions or during her New York trips, the tall stafflike sculptures influenced by primitivism made by Frederick Kiesler or Louise Bourgeois in the late 1950s and the 1960s. Referring to the totems of the Northwest Coast Indians, these sculptures stacked assorted geometric shapes to be read vertically. In Kiesler's case, as seen in his work *Totem for All Religions*, the heavenward thrust of the sculpture was also intended for spiritual interpretation, as the Indians themselves had intended.

Connell's response to these influences led to the development in the early 1960s of a group of works called the "Sunpath Series," which included, for the first time, sculpture and collage as well as painting. The Sunpath motif was a decorative geometric stylization of a round sun sitting atop the wavey lines of its reflection on Lake Bistineau waters. Usually painted bright flat reds and yellows, it confronted the viewer impersonally as though a highway sign denoting celebration. When the Sunpath works were made, Op Art and the flat brightly colored geometric paintings by the Washington Color School were in the forefront, particularly the "target" paintings of Kenneth Noland. While formally the Sunpath motif had similarities to these paintings in its shapes, hard edges, and bright colors, the substance of Connell's image referred to the spirit of an earlier target by Jasper Johns, then a leading pop artist.

Just as the pop artists were concerned with social content by exaggerating the signs and symbols of modern life, Connell had used the stylized Sunpath motif as a kind of visual notice to the world of her dauntless optimism. Moreover, the tall stacked figure could have been a detail from a primitive artwork similarly designed as an announcement of a belief. The reading of the motif can be made fairly straightforwardly using a rudimentary understanding of the psychology of

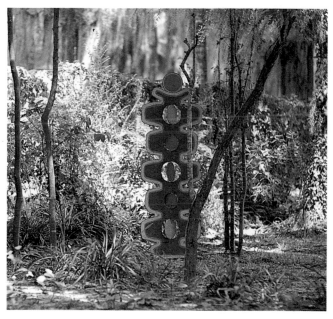

SUNPATH, *1966*
Painted steel, 52 × 20 inches
Collection of the artist

BLACK SUN, *1968*
Collage on fiberboard, 56 × 20½ inches
Collection of the artist

symbols. Glowing orbs like those in the Sunpath works may be interpreted as expressions of light and energy, "circles of life" appearing in art for centuries.* Pressing upward supported by the wavey lines functioning in a similar fashion to the "lines of force" of suprematism, they are incarnations of an ever-hopeful spirit secure in the continuity of life. Despite its rather obvious symbolism, the Sunpath iconography was the germ of a spirit and idea that would grow more complex as Connell's work matured.

The Sunpath motif gave Connell the personal symbol she needed to experiment with other matters of form and content. As she made the Sunpath works, Connell's interest in three-dimensional art grew with some of her first sculptures based on the Sunpath. By cutting out geometric shapes from thin metal or heavy

*Francis V. O'Connor, "Albert Berne and the Completion of Being: Images of Vitality and Extinction in the Last Paintings of a Ninety-six Year Old Man," in *Aging, Death, and the Completion of Being*, ed. David D. Van Tassel, p. 262.

paper and painting them flat bright colors, she transferred directly the two-dimensionality of painting to a sculptural format. In this way, she made freestanding sculpture and decorative mobiles, which sometimes had a kinetic dimension, with individual concentric circles suspended by thread between the spirals so that they danced in the wind.

The most significant immediate outgrowth of the Sunpath Series for Connell was its use in collage. Affixed to heavy board, the individual shapes of a Sunpath collage were composed of assorted materials—sand, grass, glass, dirt—painted the usual bright, primary colors. This craftlike experimentation with various textures quickly led Connell to assemblage in which she hammered nails and "found" objects onto Sunpath shapes. Even more than the freestanding sculptures, these assemblages were Connell's first genuine contact with the plasticity of three dimensions.

Collage and assemblage were particularly appropriate media for Connell. Surrounded by the rubble of building a new house—lumber, sheetrock, packing

34

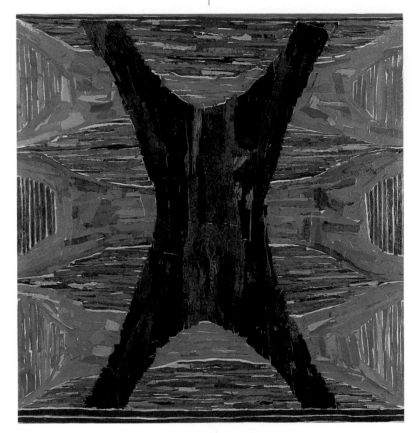

AXE TENSION, *1969*
Collage on fiberboard, 60 × 54 inches
Private collection, Shreveport, Louisiana

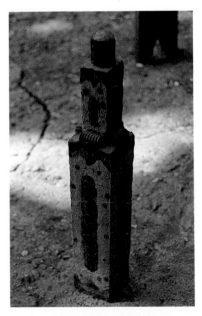

LITTLE TOWER, *1969*
Mixed media, 15 × 4 inches
Private collection, Shreveport, Louisiana

papers, corrugated cardboard—not to mention what seemed to be the rubble of her entire life, she had ample materials at hand at a time when she could not afford to buy more-sophisticated supplies. Collage also enabled her to draw on her training in art education, which had advocated the use of simple materials in complex ways. Moreover, because collage had been used as a medium in cubism and surrealism, it allowed Connell to keep her work within the tradition of mainstream twentieth-century art. Both these movements had elevated commonplace materials to new aesthetic positions, the cubists by using patterned papers to simulate texture and dimension, and the surrealists by juxtaposing disparate materials to produce the illusion of reality dysfunction. Picked up by chance, the "found" papers of the surrealists carried with them their own sense of history, just as the corrugated packing papers and scraps of sheetrock found in the rubble at Lake Bistineau were part of Connell's personal history.

In her exploration with collage, Connell ventured beyond the relatively safe, neutral image of the Sunpath. One figure, which she never repeated, was a searing prelude to her work to come. In the *Axe Tension* collage, what appeared to be a rough brown animal skin made of collaged papers was stretched symmetrically across the picture plane as though pulled on a rack. Bare and naked, the shape with outstretched arms and legs could have been a primitive headless human figure lying prostrate across a pattern of similarly outstretched figures. For Connell the piece expressed visual tension, but it also had anthropomorphic associations. Later on, Connell would refer to the "skins" of her sculptures as though, like this collage, they contained another life within.

Despite their relationship to collage and Connell's interest in the unconscious, surrealistic devices did not overtly appear in any of Connell's work until the early 1970s. She then began work on a major series of wall hangings called "Swamp Songs," which had been directly inspired by Adolph Gottlieb's synesthetic works of the early 1950s. In these works, Connell made use of surrealistic devices like automatic writing and free association to call into play her interest in psychology, primitive art, the spirituality of nature, and the emotional power of sound. Synesthetic fusions of sight and sound, the Swamp Songs were the visual transcriptions of the "music" of nature that Connell heard at night in the bayous of Lake Bistineau. Not content to limit her cross-perceptual experiment to sight and sound alone, she made the Swamp Songs relieflike, highly tactile with rows of tiny ridges built up from layers of brown packing papers and cloth. As though to reaffirm the work's connection to nature, she frequently tinted the final pieces with washes made from water mixed with red sienna Louisiana clay.

The Swamp Songs consist of random pseudo-lingual notations for individual swamp sounds. These simple shapes and patterns drawn with graphite or charcoal on the collaged papers were placed in rows within the grid of the raised ridges of paper as though lines of a manuscript. The Swamp Songs lexicon was wide, including cross-hatchings, dots, circles, flowing irregular lines, biomorphic shapes, boxes, and crosses. There is no sound "code" for deciphering meaning from the long, neatly lined scrolls of the Swamp Songs. Like the automatic writing of the surrealists whereby the unconscious reveals itself in its simplest, most direct form, Connell cannot translate her marks into verbal language. Instead, as Connell explains, "no one thing means any particular thing. The differential quality of song makes the different movements. Some of the tones are strong, some not so strong." Yet something of the almost thunderous cacophony of night bayou sounds can be discerned by the sheer density and various weights of the black marks.

The mythical content implied in the Sunpath sculptures became explicit with the Swamp Songs. The yellows, browns, and blacks of faded papers gave them the

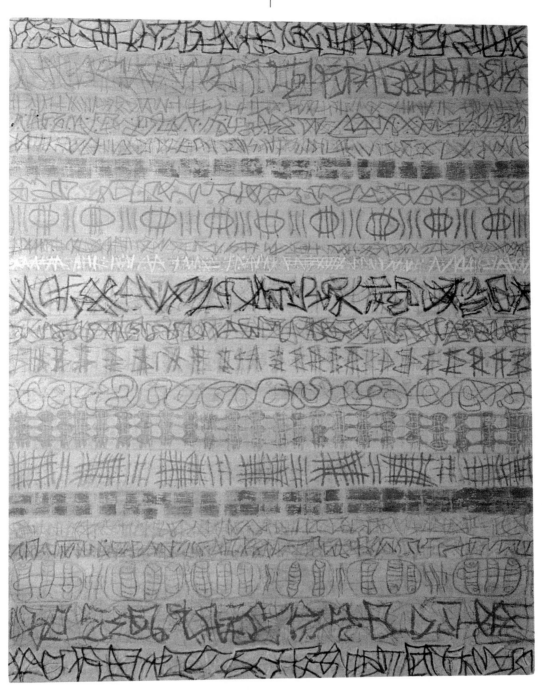

NIGHT SOUNDS, *1979*
Mixed media collage, 72 × 60 inches
Private collection, Austin, Texas

wise look of ancient scripture. Measuring as large as five by nine feet, the sheer scale of the Swamp Songs inspired awe and respect. Yet the power of these works was not solely dependent on artistic pyrotechnics, for there was a rigid intellectual order also at work. The regularity of the horizontal transcriptions reflected not unfettered response to nature but the disciplined intellectual order that Connell admired in the minimalists. Once again, in this reference to "primitivization," Connell focused on the inherent structure of nature, not its chaos.

The attraction to three-dimensionality, stimulated by the Sunpath sculptures, was heightened by the Swamp Song reliefs. Connell has used steel for a few Sunpath sculptures and made drawings for more. But she found that steel was financially out of the question. "I was full of ideas and thought maybe I could afford steel. So I made lots of designs and went down to see what it would take to get one about so-big fabricated. It would cost $600. Maybe I could make one a year but that wouldn't do. I really wanted to work." A similar predicament finding workable materials had led to the collages, and so once again Connell began to improvise for sculpture. She experimented with chicken wire but found that it rusted too badly. She then turned to discarded iron parts from the Belcher farm. Her son Bryan, by then a Belcher cotton farmer, began to bring her odd objects he found in the fields: fragments of old tractors and machines, discarded nails and bolts, chains, even stove grates. Connell was fascinated with the animistic life of these "found objects," these mechanical bits removed from their ordinary worlds. The references to her own plantation past made them doubly meaningful for Connell. Soon, the cedar fence around the cabin became a spontaneous assemblage covered with hanging iron machine parts.

Connell began making assemblage sculpture, a kind of three-dimensional collage, with the "found objects" by hammering the iron parts into any wood she could find: pieces of discarded building wood, creosote posts, cypress logs pulled out of the lake, and, eventually, kiln-dried logs. At the time also working with collage, she used a mixture of glue and paper to bond some of the iron objects onto the wood. The glue and paper mixture evolved into a craftlike papier-mâché material, which became a "skin" covering the wood armament, with the iron part poking through. The papier-mâché, also made from the discarded papers from the construction debris for her house, was perfect for experimentation. It cost little and could be discarded if an experiment failed. "I had just started to experiment so I knew I would need a world of material. The papier-mâché process just evolved. I had to have a covering for the hammered iron, a unifying skin, so I just kept looking for something. I kept soaking the paper in water until it was right and worked like I wanted it to."

Mixing the papier-mâché to the correct consistency was a long, arduous process but resulted in a viscous material resembling clay. Connell eventually found that old newspapers made the best papier-mâché. Using only the classified sections of the *Shreveport Journal and Times* because they contained the least amount of white space, she trimmed the white edges from the pages and then crushed them individually so that all the pages were separated. Keeping the sheets separate to prevent thick bulges in the material, the paper was then placed into hot water, where it soaked until the ink began to fuse into a uniform gray. When the paper began to disintegrate, it was removed and the water squeezed from it. Now a gray pulp, the paper was mixed with Elmer's Glue and, after being worked for an hour or two, acquired the look and feel of potter's clay. With about a quarter-inch covering the wood structure, the material was good for solidifying the piece, holding various iron parts in place, and modeling. The process, originally selected for practical reasons, became a major aesthetic factor of Connell's sculpture for the next twenty years. When it had cured, the papier-mâché was similar to other organic

materials, especially wasps' nests or rough gray stone. Placed around and on top of hammered nails and iron parts, the unpainted papier-mâché was soon streaked with streams of red rust, adding to the metaphorical impact of the sculptures. Like blood-red tears emanating from the residue of a lost culture, the rust stains contributed to the works a sense of poignant history.

The first sculptures that Connell made in the late 1960s with this new process were distinctly primitive in spirit, looking as though they had sprung from the Lake Bistineau swamp itself. Tall and spindly, the gray-and-black-encrusted figures coated with protective polyurethane and hidden among the moss-covered trees in Connell's yard were like shadowy specters from a primeval world. Just as the Sunpath sculptures were often topped with a golden orb, these dignified figures had as "faces" yellow or red light reflectors from old vehicles. Called "Earth Figures," they traveled alone or in groups of three or more, silent tribes of beings whose only home was the forest, which seemed to nourish and protect them. Resembling some African fetishes, these sculptures had hair made from black fishing line, and some had metal bits studded in their crusty skin. ". . . I was thinking, nobody is going to look at these sculptures. Nobody was coming here. It was just for me because I wanted to do it in the context of what had happened. I said to myself, 'I'm just going to start to make sculpture because I think it would be great if there were sculptures out here under the trees.'"

In embracing forms with affinities to primitive art, the Earth Figures were acknowledgments of the influence that Afro-American culture had had on Connell. Like the reliquary figures of primitive art, they became the guardians and sentinels that watched over the passage of the soul after death in the journey to heaven. They also had social meaning related specifically to the civil rights struggle of blacks in the South. "These sculptures were definitely influenced by conditions at the time. They have something to do with ex-

perience and life, trying to understand what happens to people and why." Many of the processes of social interaction used in her religious activism became themes of the sculpture: group membership, acceptance of social responsibility, dialogue and communication, discord and agreement, cultural continuity. The family, interpreted in the "family of man" idea of ecumenicalism, was a frequent theme that also related to Connell's own sense of family. The Family Group sculptures, part of the Earth Figures series, usually consisted of semi-abstract human figures either arranged separately in groups or bound together in an organic abstract form reminiscent of Henry Moore's figure sculptures. One such family group she called *Burden Bearers*, echoing the language of black oppression and suggesting the collective responsibility of the family of humans. Another was called *Three in Agreement* because, says Connell, "that's what a family is." Communication and dialogue, as continuations of the themes of social interaction, were first established as subjects in Connell's work in 1973 by *Gate of the East Wind*, which with *Gate of the South Wind* was one of two works originally conceived as components of a four-part series. Similarly, a heavy chain suspended over a huge stone embedded with a 350-million-year-old fossil and "a black shark's tooth" made up *Forward-Backward Time Piece*, a ritual piece about the confluence of time and history.

Despite her affinity for New York, these ritualistic, anthropomorphic earth sculptures with their layer of social commentary had little to do with the cool intellectualism of mainstream East Coast art. Her work was better received in California, where she received her first gallery representation, from 1974 to 1976 at the Bauman Gallery in Los Angeles. Not until she saw the work of Eva Hesse, the German-born minimalist artist working in New York in the late 1960s, was Connell able to bring together her disparate artistic and social interests. Hesse's exploration with unorthodox, nonbeautiful materials—fiberglass, latex, and other rubbery syn-

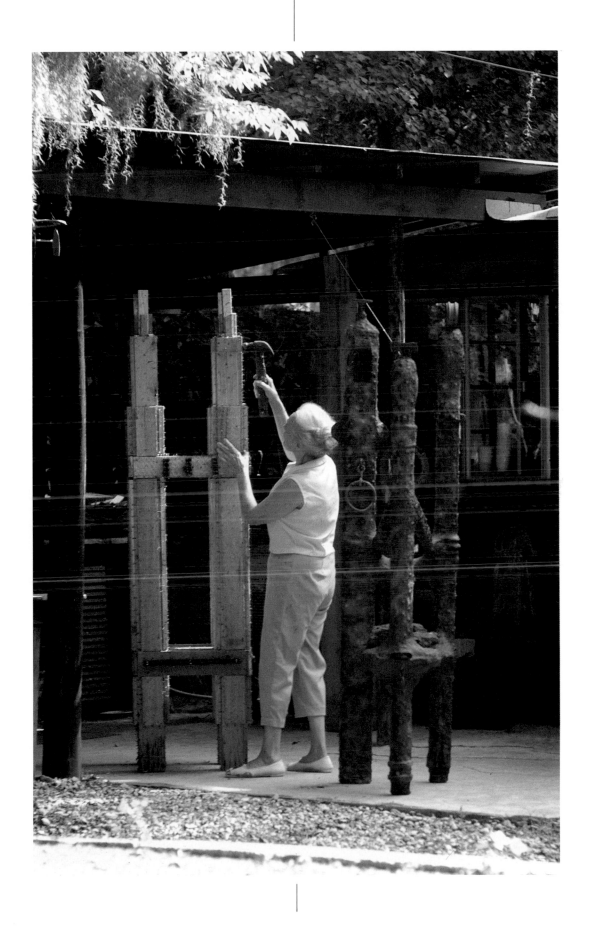

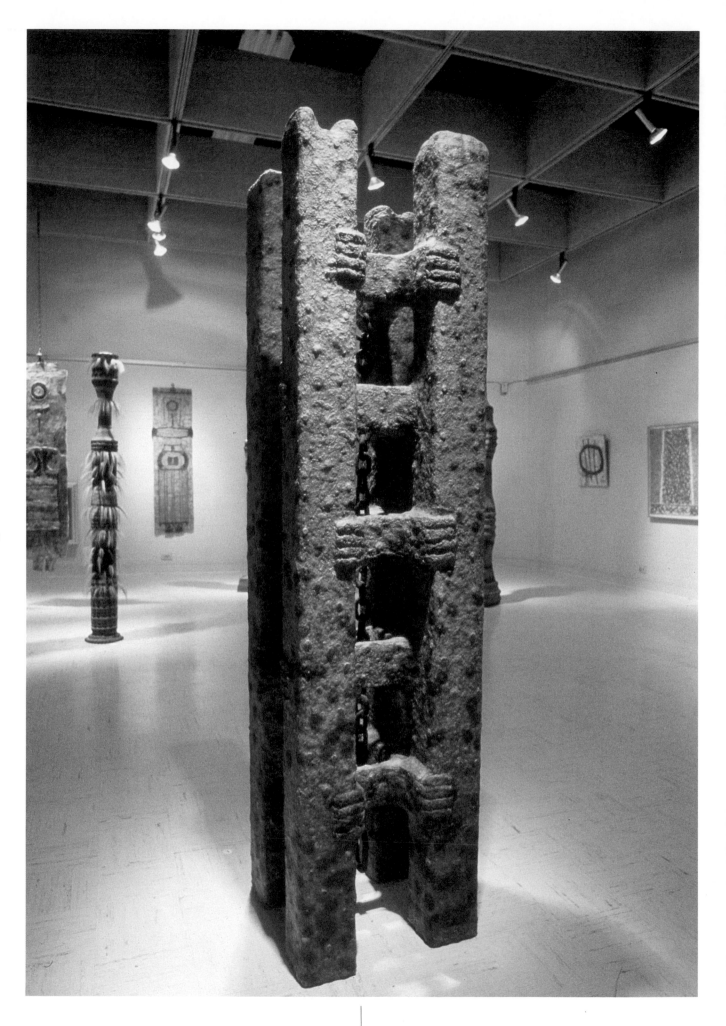

thetics—appealed to Connell, who was then experimenting with unusual, unattractive materials. When she first learned through the art journals about Hesse and her work, Connell was nearly seventy years old, yet, despite her years, she had never before been so moved by the work of an artist of her own sex. An artist haunted by insecurities throughout her short life (she died in 1970 at age thirty-five), Hesse captured a spirit of psychological vulnerability in her work that made her an early heroine of feminist artists. She died before the feminist movement had a major effect on the art world but she nevertheless was an early proponent of using a woman's experience as artistic content.

With Hesse, Connell was first introduced to women's imagery. In Hesse's work, she saw the animism she wanted for her work in the artist's visceral, often excruciating explorations of the human body. "No matter what it was, it looked like it had life in it . . . When I work, I don't try to put too much into it except that 'deep' quality," Connell said. "Eva Hesse has it in her work." Furthermore, the artists shared not only a sensibility about materials but also a perception about the formal nature of art. The dogma of minimalism implied that ordered perceptions required more advanced and rigorous thought than did organic ones. Connell, despite her own pull toward expressionism, similarly put great value on formal order in a philosophy that endowed nature with a higher intelligence. Though few of Hesse's stylistic elements ever found their way into Connell's work, the spirit motivating Hesse continued to inspire Connell.

Exposure to such ideas strengthened Connell's resolve to find a uniquely personal sculptural style, developed in near solitude at Lake Bistineau. Little of this early work was then seen publicly. During the 1960s, when her Bistineau aesthetic was being developed, she lacked funds to ship pieces out for juried competitions. She first showed the Sunpath works in 1971 in an exhibit sponsored by her own Contemporary Art Group, and in 1972 an Earth Figure sculpture was included in the Invitational Craft Exhibit sponsored by Shreveport's Barnwell Art Center. Though she had been making art full-time for more than a decade, Connell did not receive a one-woman show until 1973, when she was seventy-two years old. In that year, she was given two solo shows at the Alexandria and Shreveport campuses of Louisiana State University, where her Earth Figures, Swamp Songs, and collages were shown together for the first time.

Connell found most support for her work from other artists, particularly a handful of women artists in their thirties and forties. She joined this group of progressive Shreveport artists in renting in the late 1970s an old downtown office building for studio space, which they called the Cotton Street loft. They devoured New York art magazines, acquainting themselves with the perspectives of mainstream art, critics, and artists. Formed at a time when the women's art movement was at a peak, the group became a de facto consciousness-raising group about women's art issues.

On the other hand, Connell's family viewed her art making with more detachment. While her children generally supported her art activity—her son Dixon had handled arrangements for the show at the Alexandria-LSU campus—they were often befuddled by it. Her husband and mother appeared to consider it an elaborate hobby. Connell recalls the time when, at age seventy-five, she visited her ninety-year-old mother after one of her exhibitions. She was wearing her usual working artist attire of jeans and a blue denim workshirt, in which she had appeared in a newspaper photograph publicizing the exhibition. Upon Connell's departure from the visit, her mother complimented her on the photo, handed her a pouch of money, and tactfully suggested she buy a dress.

Around 1977, during the years of the Cotton Street loft, Connell began a new collage series called "Non-Persons," which addressed the issue of women's role

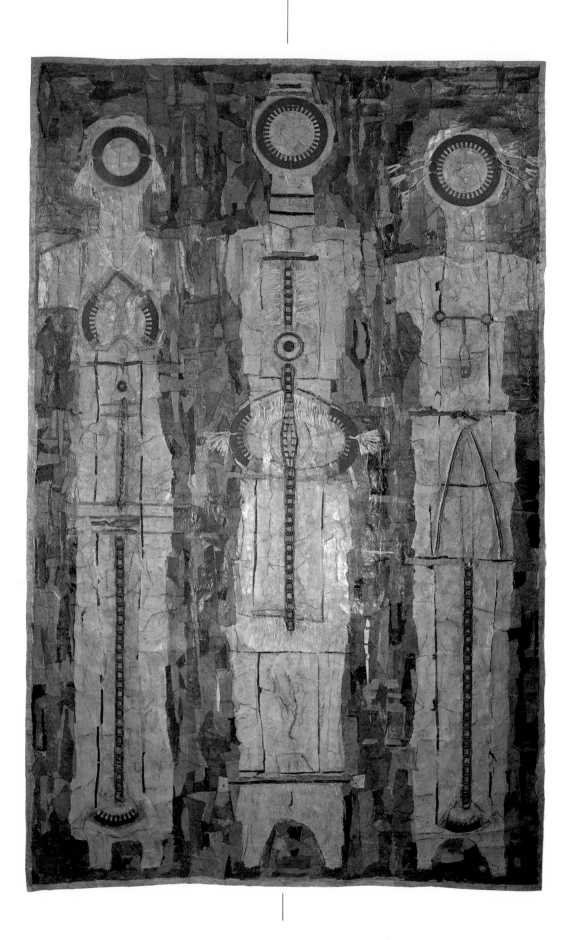

42

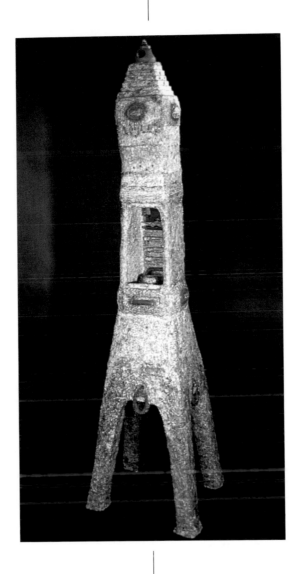

in family relationships. The inspiration for the collages came, according to Connell, from a visit to her own daughter in Pennsylvania, where she had seen women watching their daughters "with a restless look in their eyes. They had no particular interest in what their daughters were doing," Connell recalls. She interpreted these mothers—women probably of her own generation—as being disengaged from life. These disengaged nonpersons, as depicted in the collages, were clearly female with definable genitalia and heads but no faces. Larger than life-size wall hangings, they were assembled like the Earth Figure sculptures, sometimes using cups for breasts and machine gears in the genital area. Machine parts defined the heads, chains and gear shifts designated limbs and body parts, and feathers and fibers provided accents. With all the clutter of objects on the surface, these collages had a more fragmented feel to them than did the calmer, more meditative Swamp Song collages.

With the collages, Connell transferred the idea of an oppressed people from her experience with southern blacks to her experience as a woman. The figures of the Non-Person collages may be read as feminist icons or as archetypes of the enchained mother. Whatever their specific reference, these collages were groundbreaking for Connell because they addressed the final taboo subject of her generation: sex.

NON-PERSON WOMAN, *1977*
Mixed media collage, 80 × 20 inches
Private collection, Dallas, Texas

Opposite page:
WOODS HABITAT, *1979*
Rattan and mixed media, 87 × 23 × 19 inches
Private collection, Dallas, Texas

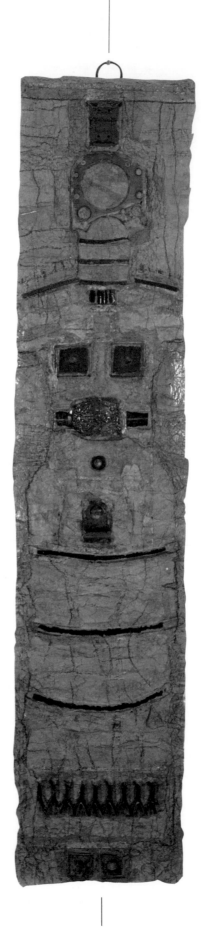

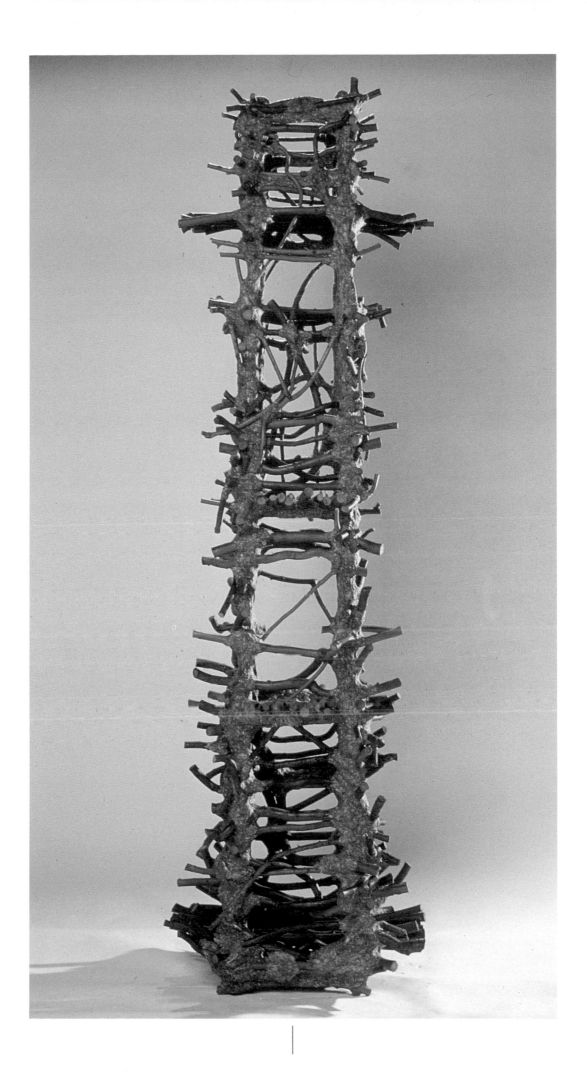

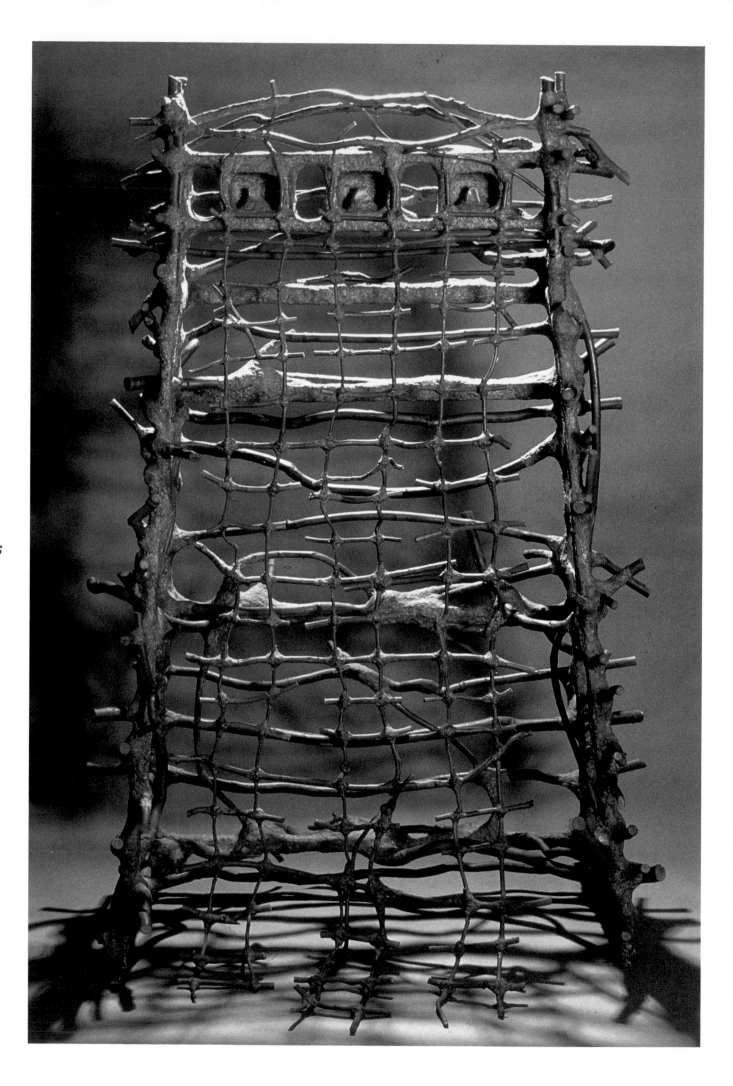

SWAMP RITUAL, *1978*
Mixed media, 81 × 24 × 22 inches
Collection, Atlantic-Richfield Corporation, Dallas, Texas

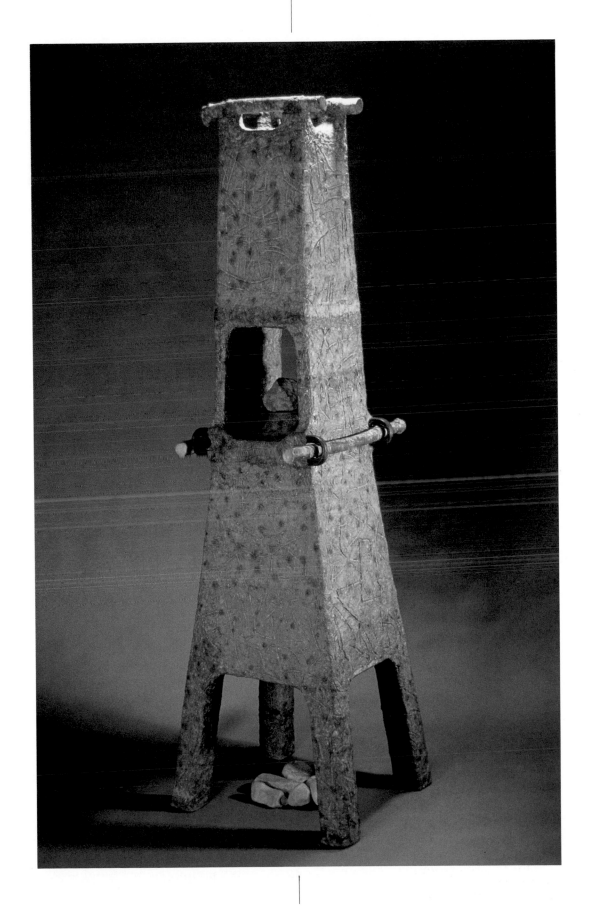

The 1970s witnessed radical changes in the American art scene. After more than a decade of formalist art, the human dimension was back in style. The stylistic chaos that entered the art world under the aegis of artistic pluralism grew out of the political activism of the Vietnam era and its rejection of any cultural policy where individual morality was not considered. The art world pluralism of the 1970s also had geographical and economic ramifications, resulting in a marked decentralization of cultural activity outside of the country's major urban centers. Women and minority artists traditionally excluded from art world hierarchies demanded, and received, more attention than ever. The regions of the United States were suddenly scoured by curators and critics seeking fresh art ideas, and by dealers looking for new markets.

No American region profited more from this cultural reassessment than Texas, which in the 1970s experienced a cultural boom of major proportions. As a new marketplace for art ideas in the then economically thriving Sunbelt, Texas received a flood of art world influences from New York during the seventies, leading to the opening or modernization of numerous art museums and the arrival of Texas branches of leading New York galleries.* Even in remote Lake Bistineau, some fifteen miles from the Texas border, Connell felt the winds of change brought by the pluralism of the 1970s and she too was soon caught up in the excitement. Because of its proximity to East Texas, Shreveport and its artists benefited from the reverberations of the Texas art boom. Louisiana visitors, primarily curators, artists, and writers who had heard about Connell, began making the seventeen-mile trek from Shreveport to see her work. By the mid-1970s, her Lake Bistineau studio had been transformed from a lonely place of exile to a bustling satellite of the Shreveport art scene. With her new

* For background, see Charlotte Moser, "Texas Museums: Gambling for Big Change," *ART-news*, December 1979, p. 96.

friends, Connell traveled into the city for lectures or meetings and, later on, to visit museums and galleries in larger regional art centers like Dallas and Houston. If no ride into town was available, the artist, now in her seventies, would catch the rural route bus into Shreveport when it stopped in Elm Grove, the town nearest Lake Bistineau. At a time when her individual style was starting to gel, the bus ride was an effort that Connell was willing to make because contact with artists and studio talk had now become critical.

The years 1975 to 1981 were a watershed period for Connell when many of the ideas developed at Lake Bistineau began to find favor in the changing art mood. During these years, she produced her first mature group of sculpture, the "Post and Gate Series," which would first bring her national attention and included the Sentinels, Ritual Places, Habitats, Ladders, and Nests. Taken in sequence, these works constitute a gradual synthesis of complex minimalist ideas with Connell's own romantic interpretation of the mystical powers of nature. By the early 1980s, the conceptual component of her work had practically overtaken its more romantic aspects in a culmination of Connell's lifelong attraction to abstraction. In the early seventies, however, Connell was still engaged in the romantic and personal. Alluded to in the assemblage Earth Figures, her plantation background now played a central role in the Post and Gate sculptures. Instead of depending on aging farm machinery to conjure up a nostalgic sense of her agricultural past, this series relied on the structural markers that people had imposed on the fields—fence posts and cattle gates—to explore the more psychological boundaries of farm life. She was now most concerned with what effect living close to nature in open country had on one's sense of time and space, particularly the special sensibility that accompanied the plantation era's relationship to nature. As symbols, the posts and gates grew out of the existential philosophy that Connell had evolved at Bistineau. In a culture where ownership

of land was a major part of an individual's identity, these posts and gates not only plotted the legal boundaries of one's land but also operationally defined the psychological, or spatial, limitations of one's life on earth. In farm fields, where they often survived the owners who installed them, the posts and gates served as memorials of the human beings who once worked the fields. As memorials, the Post and Gate sculptures bore notable resemblance to the headstones in the black graveyard that Connell once depicted. Like the African reliquary figures suggested by the Earth Figures, the Post and Gate sculptures became markers not only for the journey through life but also for the passage of the traditional southern agrarian culture into history.

Communication gradually became a preoccupying theme for Connell. She saw in it the key to her inner life, the life that would direct her art onto paths meaningful to its viewers. "I'm not after anything that would reveal me," she said. "I want to do something to draw people to the interior, hoping they'll have a response." This position echoed the sentiments that philosopher Paul Ricoeur expressed in his 1955 book *History and Truth*, where he identified communication as the only way to emerge from the narrowness of the human condition in the search of truth. He writes: "For on the road that ascends from my situation toward the truth, there is only one way of moving beyond myself, and this is communication. I have only one means of emerging from myself: I must be able to live within another. Communication is a structure of true knowledge."* *Gate of the South Wind* (1973), one of two works executed in a series conceived as the "Gates of the Four Winds," was the first sculpture using the theme of communication. This work was also a transitional piece between works whose form was determined by specific social content and those for which form itself was endowed with meaning. A group sculpture like the earlier Family Group

*Paul Ricoeur, *History and Truth*, p. 51.

sculptures, *Gate of the South Wind* employed a more complex geometric format. Arranged in a square, four stylized rectangular corner figures were joined by their clasped arms enclosing a tall rectangular space. The configuration of clasped arms suggested a geometric ladder, a motif that along with the enclosed space would later gain prominence in Connell's work. Down the middle of the empty interior space, Connell hung a heavy chain of the sort that might be found in a farm field but that also suggested a slave chain. Connell's use of the posts and gates as a metaphor for communication is clear when she describes the meaning of the sculpture. The gate was an "entranceway," she explains, "an abstract symbol meaning communication," which provided access to a "new territory, new idea territory." The chain represented the gate "let down for greater communication."

Gate of the South Wind was an important sculpture because it departed from the contained monolithic figure of the Earth Figures. The Sentinel Figures that followed, however, returned to the earlier format as totemic spin-offs from the assemblage-inspired group sculptures. Tall and monumental, encrusted with pieces of iron bleeding through the gray papier-mâché, the sculptures had a poetic authority absent in the earlier, more organic pieces. The modeled gray papier-mâché "skin" of these simple iconic works simulated hard chiseled granite, giving them—like granite headstones—a sense of permanence and eternal watchfulness, unwavering markers along the human passage through time.

The breakthrough for the Post and Gate sculptures came in the late 1970s when members of the Cotton Street loft started organizing public lectures about contemporary art. Of particular interest to them was what was happening in the women's art movement, since, as women artists, the Cotton Street group wanted to explore notions of women's imagery. Because no Shreveport institution fostered an interest in avant-garde art ideas, the artists themselves pooled their money to invite na-

tional art figures to Shreveport. The purpose of the visits ostensibly was to hear these artists and critics lecture about issues in contemporary art. However, an ingenious part of the agenda also consisted of getting feedback from the visitors about the group's work, which, despite the seriousness of the Shreveport artists, rarely received critical response. This program, which helped Connell shed what provincialism remained in her art, both relieved the sense of isolation of these artists and reduced somewhat the informational gap between art making on the two coasts and art in the regions.

From 1976 to 1979, four women artists and critics visited Shreveport. Lucy Lippard, the nation's leading feminist art critic, came first from New York, followed by California feminist artist Judy Chicago, artist Jackie Winsor, and then New York art critic Roberta Smith. Writing in *Ocular* about her visit, Lippard was struck by the group's intensity. "There are not many more desolate spots for artists than Shreveport, Louisiana, and I shudder to think of the support they don't have. They have banded together not as feminists as much as a support group—which of course is a basic feminist idea. They asked if I thought they were doing anything different and I said I thought they were doing international art. But the sensibilities and the content come out of the artist herself and her experience and that's more interesting than the styles."*

Of the four visitors, Judy Chicago had the biggest impact on Connell's work. A founder of the Feminist Art Program at California Institute of the Arts, Chicago was a leading theoretician in identifying female imagery in art during the 1970s. Chicago considered female imagery ultimately to be a response to the woman's body, finding a preponderance of what she called "central core imagery" in art by women. In an article entitled "Female Imagery" published by *Womanspace Journal* in 1973, Chicago stated that "women artists have used the central cavity which

defines them as women as the framework for an imagery which allows for the complete reversal of the way in which women are seen in the culture."* Most frequently, the central image was expressed through a flower form surrounded by folds or undulations as in the structure of the vagina, but a central cavity had also been used in similar ways by women sculptures, such as Lee Bontecou and Barbara Hepworth.

Like the other visiting art personalities, Chicago was invited to view the work by the Shreveport women at the Cotton Street loft. When she saw Connell's work, Chicago was delighted but, according to Connell, her response was unexpected. "'Clyde, your figures are too stoical,' Judy told me, 'Why do they stand there like that? What have they got on the inside? Tear their hair, tear their clothes, rip them open. Let their nails show.' Well, you know I'd never do all that. So I said, 'Now Judy, that's you. I don't do that. But maybe I'll open them up and see what's inside.' Judy came and went, but I started to think. Eight months later, I opened up my first piece and a ritual place was inside it. That's what happened." Into the impassive front of the totems, Connell had inserted a small deep womblike cubicle as though carved out of stone. However, instead of identifying the central cavity in sexual terms, Connell viewed the space as a mystical reliquary where she placed small objects from nature—pebbles, hickory twigs, pine needles. "I began to think about putting things in there, of having a gathering place not for mementos but for things you wanted to save. The ritual place is an inner sanctuary. Sometimes I think it's related to the fact of the growth of philosophy that everybody has this interior space."

In her visit, Chicago not only gave Connell a first-hand introduction to feminist imagery but also reaffirmed her longstanding interest in ritual, then being associated with earth-related art. These works, to which Connell gave the overall

*Lucy Lippard, *Ocular 1549*, p. 40.

*Judy Chicago, *Through the Flower: My Struggle as a Woman Artist*, p. 144.

51

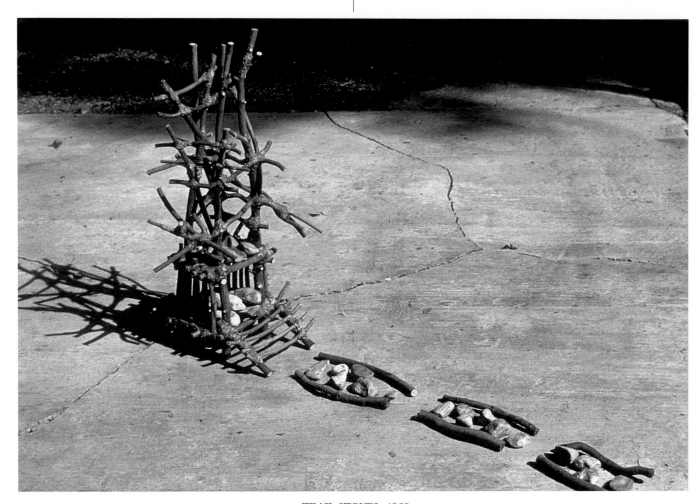

TRAIL STONES, *1980*
Wood and stone, 35 × 20 × 58 inches
Collection of the artist

name of Ritual Places and which included the Habitat sculptures, can be interpreted from various perspectives. Romantic and fanciful, the somber totems with their inner sanctuaries were like miniature religious shrines used by forest sprites in a ritualistic worship of nature. To protect the power bestowed on all nature's riches, the offerings from the bayou were brought to the shrine for safekeeping, as if the beneficence of nature were under constant threat. Indeed, read autobiographically, the sanctuary of the interior space could be viewed as Lake Bistineau itself, to which Connell had entrusted herself when all other reality seemed threatened. Since she saw human life as being as much a part of nature as flora and fauna, the pebbles and hickory twigs in the cavities represented humanity, the precious entity being preserved in the sanctuary. "The Habitat idea first developed as a place where animals or people could gather. I never say spirits. It has more to do with the relationship between people than being a dwelling. It's about closeness, communication, openness, sharing, being connected." As a secure dwelling place in which organisms live naturally, the habitat referred to Connell's own psychological niche in the ecology of southern culture, a niche she shared with regional writers like William Faulkner. As a domicile, it could be associated with the happy home she had known as a child at the Dixon House or as the domain for which women as mothers were responsible. A feminist interpretation would read the habitat as a womb, the first safe home for formative life and a fundamental source of female creativity.

Connell was not alone in using the habitation idea as social content. Houses had been frequently used as symbols by surrealists. In 1933, Paul Tillich had applied his theory of cultural theology to domestic architecture. A house, he wrote, was not merely a "dwelling machine" but an ambiguous structure in which rational purposes have to be combined with inner symbolic power for the life of its inhabitants. "For in the nearest things to us, in that which concerns our daily life, in the apparently trivial thing something metaphysical really hides. The here-and-now is the place where our existence must find an interpretation if it is to find one at all."[*] Frederick Kiesler had given a phenomenological description of his work *The Endless House* at the Museum of Modern Art in 1959 as a place where "the events of life are your houseguests."[†] Connell's own ideological concerns that the people of the world could live together in harmony had previously been expressed in the Family Group and Wandering Group sculptures.

The safe, gathering "place" of the Ritual Places sculptures was an expansion of the personal site-specific references of the Post and Gate Series. In addition to being markers of ownership, farm fence posts and cattle gates defined in the South a unique entity of the mental landscape: the plantation. Throughout the South even until the present day, large farms, of which plantations with upward of 10,000 acres were the largest, have been referred to as "places." In the Dixon family, for instance, the Clyde plantation was routinely called the Clyde Place as a more informal, somehow more familiar designation of what was essentially merely a piece of ground. Furthermore, the word *place* itself has intimate connotations, suggesting an area with definite boundaries, a proper niche to which something rightfully belongs. It even connotes social status. No geographical region has a more clearly defined sense of "place" than the South, both physically and sociologically. Thus, for Connell, the Post and Gate sculptures, particularly the Habitats, defined a specific, wide-ranging emotional place. They became metaphorical markers circumscribing the boundaries of her own niche in time defined by her family heritage, the events of her life, and, ultimately, her philosophy of life.

[*] Adams, *Paul Tillich's Philosophy of Culture, Science, and Religion*, p. 98.
[†] Kiesler, *Inside the Endless House*, p. 567.

One can also link the "ritual" aspect of the Ritual Places to Connell's past, which had been amply enriched by social and religious ceremony. The southern lifestyle, particularly during the plantation period, was filled with strict rituals of social behavior, helping to prolong the viability of antebellum culture. Agriculture everywhere has its seasonal rituals, planting and harvesting cotton crops and praying for rain. Connell herself engaged in one southern agricultural ritual. Just as farmers had burned unwanted or unsatisfactory cotton, each year she burned unsatisfactory residue from the year's work. With the Ritual Places, however, Connell drew most directly from her understanding of black religion. The Afro-American idea of passing through earthly life on the journey to heaven, a concept fundamentally related to the time and space of human existence, was underscored in the Habitats. With the rough-hewn feel of primitive talismans placed as markers by pilgrims on a journey into the unknown, these tall, dignified sculptures became facilitators in a metaphorical ritual. The mythical nature of these works was enhanced by the pictographic scratchings, similar to those used in the Swamp Songs, that decorated the sides of the sculptures. Moreover, the obelisk shape of the Habitats echoed ancient memorial sculpture dating back to the Egyptian Temple of Karnak built around 1500 B.C. and even headstones of more modern times. Standing often seven feet high, the Habitats were tapered from a point to a broad base of four sturdy legs, pointing heavenward while the base rested squarely on the earth. Other Habitat sculptures treated the idea of life's passage by expanding the interior sanctuary so that it penetrated completely through the opposite wall. Connell pushed this idea to its extreme with a series of whimsical Habitat sculptures built not with the solid wood armament of the obelisks but with fragile, loosely woven rattan vines found in the Lake Bistineau forests. These works were virtual sieves, allowing space to flow through practically uninterrupted.

The more open, rattan Habitats superimposed a full repertoire of 1970s formal influences onto the personal content related to Lake Bistineau. A culmination of Connell's near-pantheistic relationship with nature, the works were assembled entirely from natural materials gathered during her long walks "full of discovery" through the swampy lake forests surrounding her studio. She even saw the use of her traditional papier-mâché as related to the natural "building materials" of insects, specifically the pulpy gray nests built by wasps known as "mud daubers." Used to meld the joints of the rattan vines together, the papier-mâché was more functionally integrated into these works than in its earlier more purely decorative application. In its association with nests, the material itself also suggested another form of living creature domicile, which would become a later motif. Within this organic context, Connell developed several formal components that she had previously only touched upon. The grid-based ladder configuration alluded to in *Gate of the South Wind* became a free-form "rope" ladder in the 1978 *Rain Place*, almost a crafts treatment of the idea. Taken from her admiration of Sol LeWitt and his gridded minimalist sculpture, this work was a naturalistic interpretation of minimalist sculpture, which other contemporary artists like Jackie Winsor were then exploring. In Connell's case, however, *Rain Place* was romantically related to a specific natural site within the quasi-spiritual mythology she had developed around Lake Bistineau.

Woods Habitat (1979) combined an expressionistic view of minimalist structure, regional art-making influences, and a new interest in monumentalism. It also clearly had autobiographical overtones if the "Woods" in the title is taken to mean the Woods Place, the family plantation where Connell was born. A six-foot tower of rattan twigs attached to an open obelisk-shaped support, this work projected more than did most of Connell's sculpture the rough, native intelligence of a naïve artist. In it, one can feel the heroic impulse

that lies behind other towers, like the Watts Tower in Los Angeles built by a true folk artist, Simon Rodia. Thus, *Woods Habitat* illustrates with extraordinary clarity the degree to which Connell synthesized the primordial sense of form shared by both primitive and vanguard artists of the 1970s. The romantic and intellectual embrace of the physicality of space, which heretofore had been expressed principally within the discrete object, was applied in 1980 to her first installation piece, *Trail Stones*. In it, Connell put three identical configurations of twigs and rocks on the floor in front of a three-foot-high version of the *Woods Habitat* rattan tower. These arrangements, which she called markers, were reminiscent of the loose rock-pile cairns laid by hikers to show the trail to those who followed. Though contained within a relatively small area, the work illustrates her interest both in physically reaching out to the viewer and in emphasizing the potential spontaneity behind art "in process."

Following *Trail Stones*, Connell moved away from nature as both a theme and a source of materials. In 1981, at the age of eighty, she embarked on a series of geometric sculptures, which constitute the most intellectually rigorous works of her career. The reason for this shift of emphasis is twofold. First, Connell felt that she had sufficiently explored nature as subject matter and now wanted to explore form. Interested in more monumental sculptures, she was curious about developing the open spaces introduced in the rattan Habitats so that people would want to physically "enter" the works. A natural progression of the "central cavity," which led to the "pass through," these more geometric sculptures recalled her earlier humanism because of their human scale, rather than for symbolism alone. "I wanted something big enough so that a human could walk through. Geometry helps people move through, because people are accustomed to moving through geometrical shapes like houses and furniture. I had worked through the natural, woodsy thing and wanted to focus on man-made

structures." Characteristically, she liked the intricacies of the new sculpture because "it showed the complexities of life and the complications of finding your way through things."

Second, Connell was entering a period of national visibility during which she began to subdue the more sentimental, regional aspects of her work. Interest in Connell outside Shreveport had been building since 1977, when she and other members of the Cotton Street loft group started making periodic trips to Dallas to see the contemporary shows at galleries and museums. Murray Smithers, then director of Delahunty Gallery in Dallas, was widely acknowledged as one of the best judges of a new regional aesthetic developing in Texas related to the postmodernist tendencies in art throughout the country. He remembers receiving a sheet of slides by an unknown artist from Shreveport named Clyde Connell who invited him to "stop by" if he was ever in the area. Because Connell had sent along snapshots of herself as well, Smithers saw that she was a "sweet little old lady" but thought the pictures of her sculpture were interesting enough to take a look. On one trip to Louisiana in 1978, he did indeed stop in Shreveport. "I recall clearly that she wanted me to first look at all of her friends' work and say something to each one. I was surprised it was all such good work. But, when I got to Clyde's studio, I was just overwhelmed by it all, by the way it all blended together with such strength. I believe that artists have a sense of when it's time for something to happen, that it's time to find attention. At that point, Clyde knew she was making important work." Through Smithers, Connell met Delahunty's roster of distinguished Texas artists, including James Surls, Michael Tracy, Vernon Fisher, and Jim Roche, all of whom were individually developing unique styles based on artistic concerns that echoed Connell's. Smithers also introduced her to Ron Gleason, then director of the the Tyler Art Museum in Tyler, Texas, one of the state's most innovative smaller museums. In 1979, the Tyler mu-

SOUND POST, *1981*
Mixed media, 91 × 16 × 16 inches
Private collection

Opposite page:
DIALOGUE GATE, *1981*
Mixed media, 84 × 74 × 75 inches
Collection of the artist

56

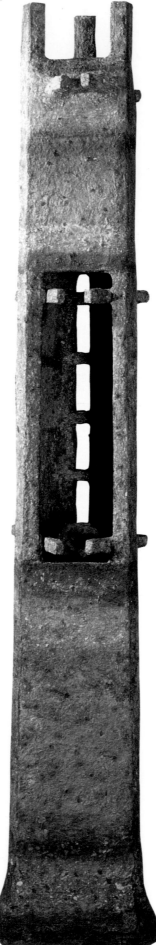

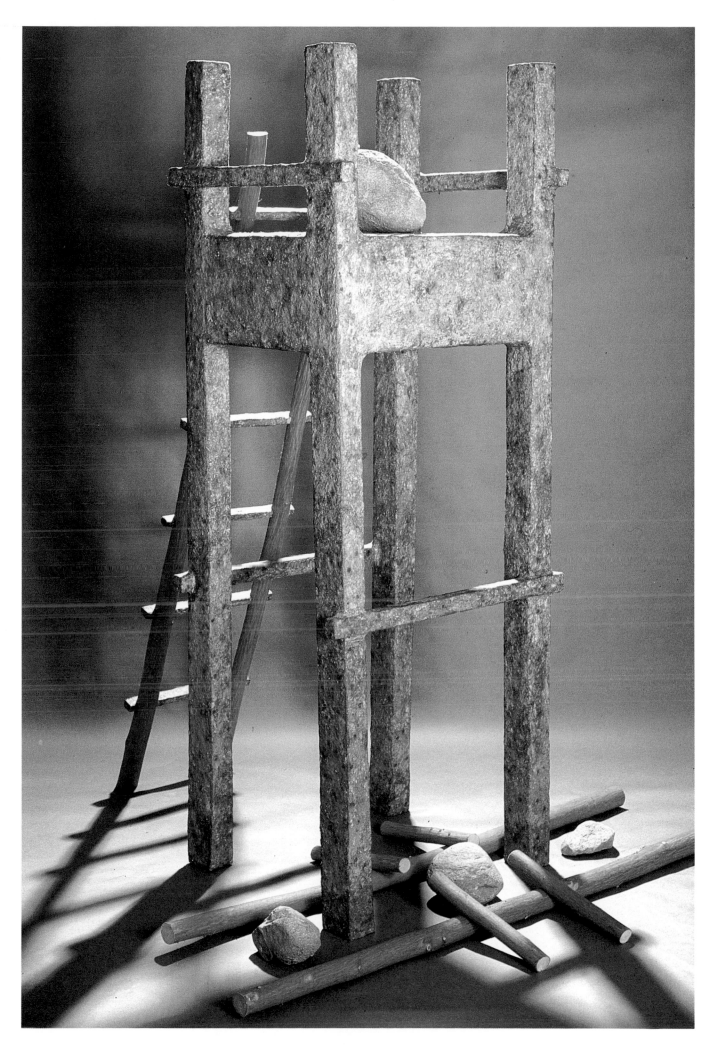

UNTITLED, *1981*
Mixed media, 102 × 45 × 57 inches
Collection of the artist

58

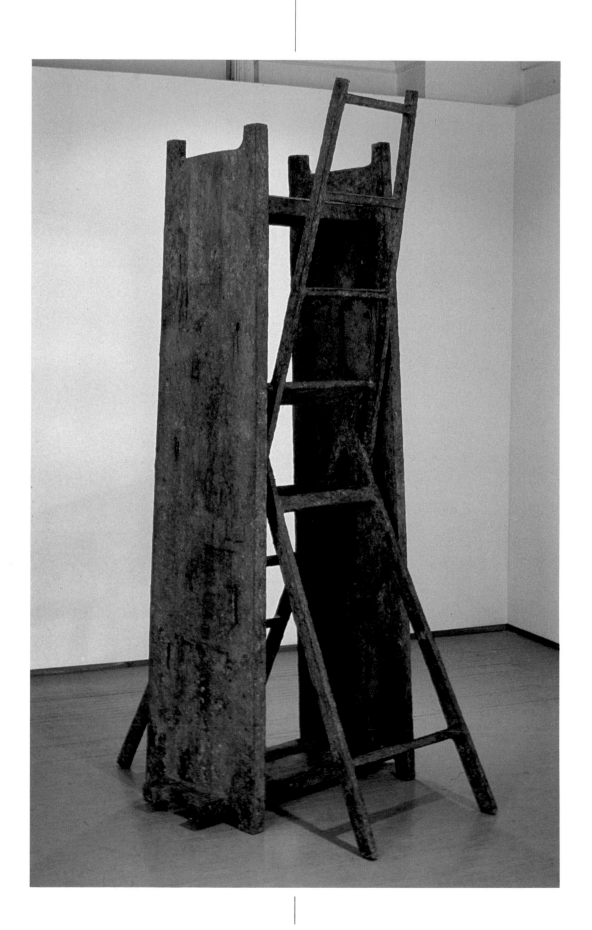

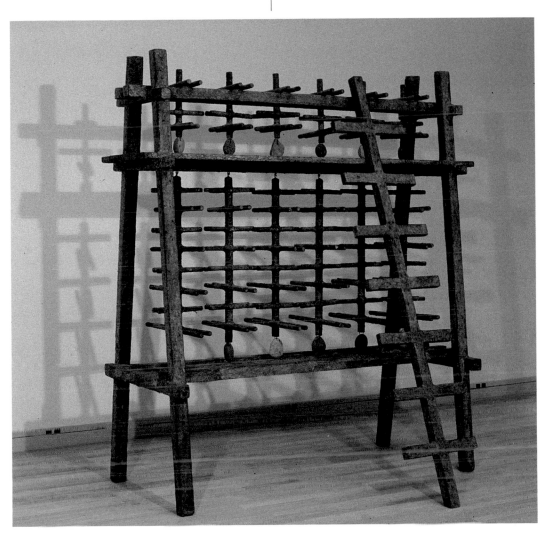

COMMUNICATION PIECE, 1982
Mixed media, 79 × 72 × 49 inches
Private collection, Dallas, Texas

60

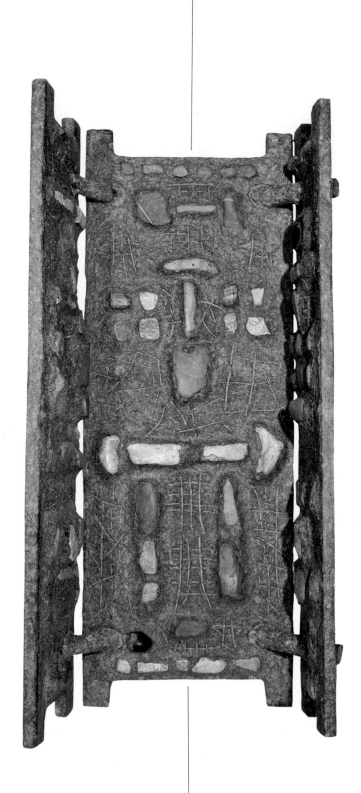

LAKE STILTS, 1982
Mixed media, 60½ × 106 inches
Private collection, Houston, Texas

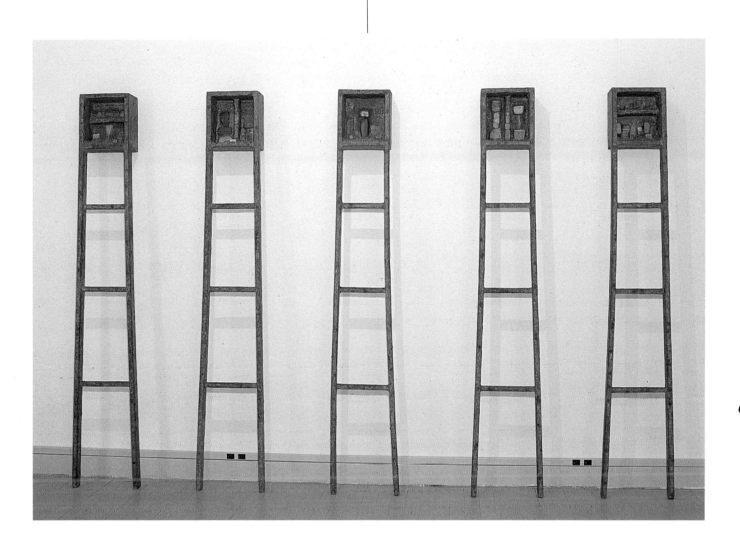

Detail, LAKE STILTS

seum gave Connell her first one-person show outside Louisiana. Later that year, the sculptor James Surls gave her a one-person show at the University of Houston's Lawndale Annex, where he was then director, introducing her to a major urban art scene.

By 1980, Clyde Connell had become a de facto member of the most progressive group of artists in Texas. Following a show in 1981 at the DW [Dallas Women's] Co-op arranged by Smithers, Delahunty Gallery began representing her. Later that year, she received the ultimate accolade for a regional artist, a New York show arranged by Delahunty at Clocktower Gallery, a city-funded "alternative" arts facility known for its vanguard exhibitions. The show opened in October 1981, the same season that a new movement, neo-expressionism, was sweeping the New York art scene. At one dinner party, Connell was seated next to the head of the Adolph Gottlieb Foundation, established by the late abstract expressionist artist to financially help artists over the age of fifty. Connell was urged to apply for funding and, later that year, was awarded a $10,000 grant. For a woman who had never earned a professional income, the amount was a staggering sum. Appropriately, it had come from a source founded by the abstract expressionist artist to whom her art was most indebted.

With the Gottlieb Foundation grant and increasing sales of her work, Connell was able for the first time to live and work like a mainstream artist. Critical maintenance repairs were made on the now-twenty-year-old concrete-block studio-house at Lake Bistineau. Working alone on her art all these years, she had had only the yardman to call upon to help with drilling the tough rattan vines and to hold the pieces together while she bound the joints with papier-mâché. Connell was now able to hire two assistants, one to help mix the papier-mâché medium, known as "the stuff," and one to help build the tall wooden sculpture armatures.

The sculpture that Connell began to produce in 1981 continued the synthesis

of personal, regional content with a non-regional internationalist formal style. As she more actively embraced the sparer, more cerebral format of minimalism, her sculpture turned away almost totally from the monolithic anthropomorphic figure and toward an expanded configuration of intersecting geometric planes and wide open areas. At the same time, the rugged carved stone feel of her work diminished as the gray papier-mâché became smoother and thinner, making more obvious the clean architecture of the wood armature. Less interested now in visual illusion than structural strength, Connell relied more heavily on sculptural shape to convey the sense of narrative content. Into this more complex, form-oriented sculpture, Connell re-introduced old themes and symbols now expressed in ambitious new ways. The journey of human life through time and space remained a central theme, exaggerated now by the frequent use of the ladder as a symbol of transit. Communication, already established as a critical element on the road to self-knowledge, was more fully developed as she entered a period of greater communication within the art world. The sanctuary, or "safe place," of the Habitats was transformed into a small, separately contained "nest," usually raised high as a bird's nest would be. The pebbles once placed in safekeeping in the sanctuaries became simulated stone boulders, enlargements of the symbol of humanity to omnipotent proportions.

The transitional sculpture in this shift to geometry came in 1981 with a group of works called "Sound Posts," the first of Connell's sculptures to use sound and the first time sound had been used as subject matter since the early synesthetic Swamp Songs collages. The Sound Posts were geometric stylizations of the Habitat obelisks of five years earlier, retaining the central altarlike cavity, where offerings of pebbles were placed. However, instead of the anthropomorphic quality of the Habitats, the Sound Posts were architectural in feel, the sloping obelisk shape replaced with rigid perpendicular sides and

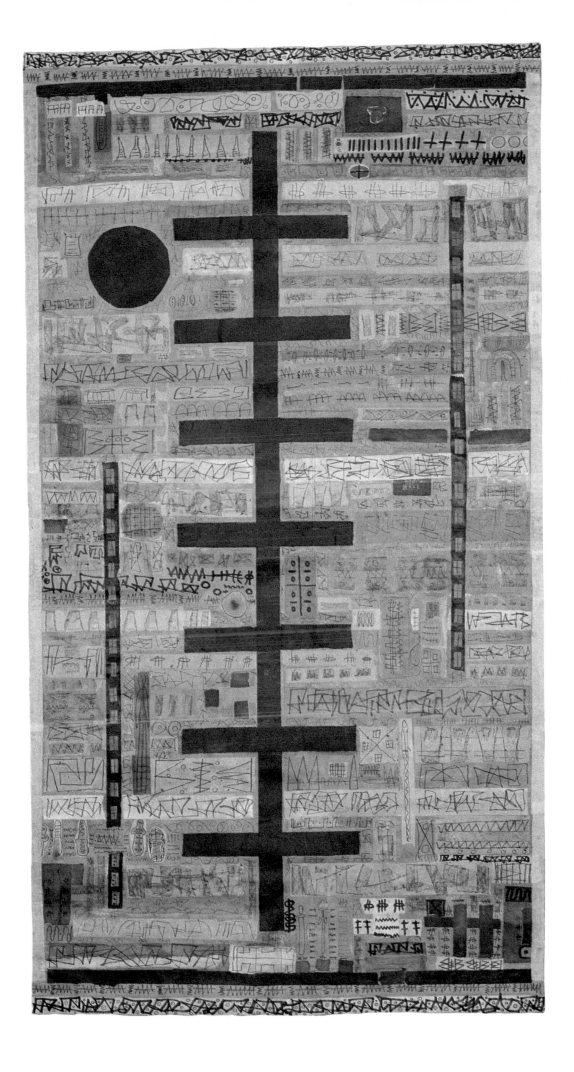

63

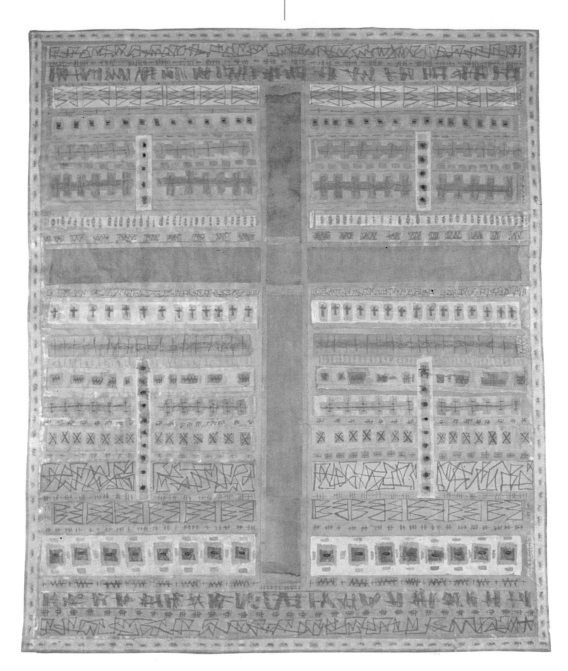

SWAMP SONG I, *1982*
Mixed media collage, 72 × 60 inches
Private collection, Austin, Texas

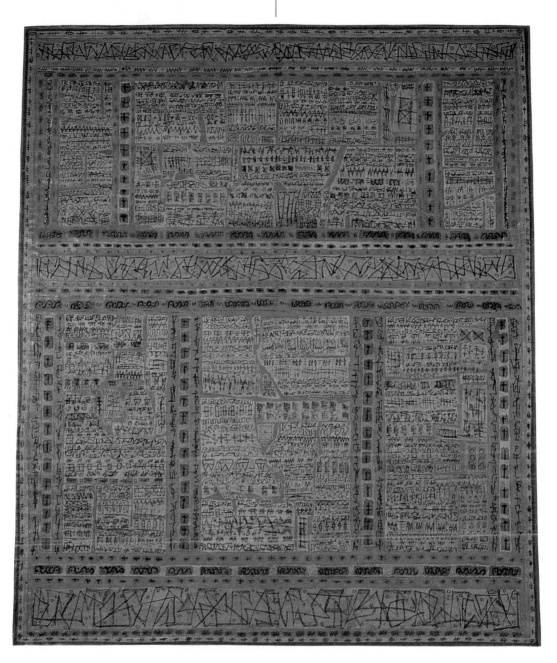

SWAMP SONG II, *1982*
Mixed media collage, 72 × 60 inches
Private collection, Austin, Texas

the mottled gray papier-mâche smoothed to look like planed concrete instead of chiseled stone. Instead of a peak, the Sound Posts were crowned with what looked like an architectural turret. Yet, despite the severity of this new work, a hint of Connell's old romance with nature remained in the Sound Posts. Down the back of the interior cavity, long slits had been cut as in primitive musical instruments, whistles to make music from the Lake Bistineau winds.

The Sound Posts sculptures were the last of the totemic-shaped sculptures made by Connell. Expanding on the geometry of the Sound Posts, she next made an untitled dark gray sculpture that stretched space beyond its physical boundaries. Two ladders—a long one and a shorter one braced against it—are propped diagonally against each other between two tall "bookend" planks. Like the ladder form suggested in the earlier rattan *Rain Habitat*, the ladders in this piece created the illusion of a solid plane even as the wide open spaces between the rungs allowed space to pass through. Further penetrating the unoccupied space, the two ladders propped together with a tight space seemed balanced to swing out horizontally on the common pivotal point, which would extend the real length and implied mass of the sculpture. The sense of precarious balance in this work stems from the top-heavy extension of the long ladder beyond the top of the bookend side boards.

While Connell viewed the ladder as simply a climbing implement, it also has an obvious relationship to her on-going interest in ascent. If the ladder is seen as kind of a Jacob's ladder extension of the Sunpaths to the heavens and obelisks pointing to the stars, then the delicate balance of the ladders in this untitled work suggests an unexpected uncertainty to her usual steady climb. Neither does this untitled piece of interlocking planes and flying ladders contain her usual symbols of rock or iron machine parts. As though a bare-bones exercise in survival, the sculpture is a sharp and abrupt statement about the inevitable pitfalls of a life.

Dialogue Gate (1981) incorporated three on-going Connell themes: gates, communication, and stone. With its human-scale architecture, the piece once again becomes an environmental tableau inviting the viewer to enter. In this work, a ladder is propped against a high, turreted platform on which a large stone has been placed. The platform represents an enlarged open version of the small interior cavities of earlier work, where only small pebbles were placed, but is now filled with a huge stone. For Connell, the symbology of the stone evolved gradually but it carried with it a history of symbolic meaning. Historically, stones have been imbued with symbolic life. In mythology, they have represented everything from childbirth to going to church. Most frequently, stone has been the symbol of earth, fertility, organic life itself. "There's something about stone that's fantastic. It has a life of its own. Almost everything deteriorates, that's a natural way of life. But stone is permanent, it can survive." Perhaps only indirectly conscious of stone's metaphorical history, Connell placed the pebbles in the Habitat cavity, which, because she called the cavity a "sanctuary of being," automatically conferred on the pebbles ontological status. Indeed, since Connell viewed the Habitat cavities as gathering places for humanity, the stones had further ontological meaning as symbolic of human life. Thus, if stones are symbols of humanity for Connell, the huge rock at the top of *Dialogue Gate* could, by proportion alone, represent composite humanity, an indication that the elevated consciousness to which she aspired was to be found among humans themselves. The ladder was the avenue for reaching that collective, spiritual presence. The platform's turreted fence served as the "gate" through which the seeker must pass.

Connell combined the dual themes of sound and communication in a 1982 work called *Communication Piece*. Like *Rain Habitat* five years earlier, this broad, high sculpture presents a sievelike maze of rods confronting the viewer as though a

screen. However, the rods are really a series of six small primitive ladders hanging in a row from crossbeams. At the end of each ladder is a perfectly round stone hung loosely so that, when struck, it would clatter with sound as though the "life" of the stone could speak. A larger, human-scale pole ladder lies diagonally against the sculpture, inviting the viewer to climb up to the controls where the rods with the dangling stones are hung and where one could become the instrumentalist activating the sound, or life, in the stones.

That stones symbolized for Connell not only biological life but also her view of the oneness of nature became more apparent in her sculpture made from 1982 to 1984. Returning to the sanctuary cubicles that she had removed from the Habitats and previously placed separately at the top of the *Rain Habitat*, she built a series of ladder pieces with what she called "nests" at the top. Connell refers to these "nests" as reminiscent of the nests in the chicken coops of the farms where she lived most of her life. Propped up on top of the ladders to prevent marauding animals from stealing the eggs, the chicken nests installed in wooden boxes were lined up in rows in sheds dimly lit to enhance the calm needed for egg-laying.

This pastoral analogy to the universal process of giving birth relates, once more, to Connell's concept of a nurturing, sacrosanct habitat. A "nest" is a place of ultimate intimacy, the supremely simple, utterly primitive home. As Gaston Bachelard has pointed out in *The Poetics of Space*, the nest found in natural surroundings becomes the center "of an entire universe, the evidence of a cosmic situation."* Similarly, because Connell's "nest" boxes contained rock "eggs," clear references to the interior life of rocks, the works became symbols of the universality of the human condition. Embedded against the back wall, these radically different stones of varied sizes and colors are, according to Connell, the "people" gathered in the nest, variegated "humans"

grouped together in a sense of harmony, the utopian universe waiting at the top of the ascent.

More akin to painting than sculpture, *Written in Stone* (1982) is a large three-dimensional panel screen of papier-mâché–covered wood embedded with large stones. The "nest" writ large, it permits a human being to enter the habitation by stepping amid the folding side panels. Monumental and meditative, like Mark Rothko's paintings in the Rothko Chapel at the University of St. Thomas in Houston, the panels have a solemn serenity, a presence quite different from the earlier more narrative work. Instead of being a guidepost of the journey, the work has the visual authority of being the journey's ultimate goal, presenting its hieroglyphics formed from rock for all to contemplate. In a similar work, called *Preying Mantis*, Connell repeats the basic format of *Written in Stone*. However, in this large architectural piece, a screen embedded with rocks is placed before a bench beneath an open canopy formed from the back of the bench. The bench is obviously intended for viewers who want to contemplate the rocks of the screen. The religious implications in these last works cannot be denied. *Written in Stone* has for its title a reference from the Old Testament. The canopy over the bench in another work, *Mantis and Man in Time and Space*, suggests the outstretched, all-enveloping arms of a stylized omnipotent figure. Though geometric in form, these works have lost none of Connell's earlier search for mythological content but aspire, instead, to more universal subject matter, echoing the goals of many contemporary conceptual artists.

In 1983, Connell's work began to change again and the process has not been completed. To work out the changes and return to a format more easily controllable, she has turned to a more intimate scale—drawing and works on paper. One important wall hanging from 1983, *Dark Side of the Moon*, is a mixed-media piece similar in format to her earlier large Swamp Songs. However, while the Swamp

* Gaston Bachelard, *The Poetics of Space*, p. 94.

Songs were organic and filled with the automatic writing of surrealism, *Dark Side of the Moon* is a tighter interplay of geometric blocks of earth tones, blacks, and whites. The pole ladder motif of the sculpture is repeated in a bold black central position on the hanging. At the top left, between the second and third rungs of the ladder, is a round black circle. It reminds one of the bright yellow sun shapes of the Sunpath sculptures and the dangling round rocks of *Communication Piece.* Reminiscent of the "circle of life," which had been a component of the Sunpath sculptures and could be interpreted as the meaning behind the round rocks of *Communication Piece,* the black moon is oddly ominous and austere. According to Connell, it is dark because "world affairs were tightening up and things were getting worse."

As though stretched to the metaphorical limits of geometry with *Dark Side of the Moon,* Connell then returned to the kind of automatic, quasi-primitive drawing she had developed more than a decade earlier at Lake Bistineau. In these bold black-and-white ink drawings, tall humanlike geometric figures hold down the center of the picture while obscure automatic writing and the graffiti of pictograms surrounding it conjure up poetic associations. The pull between the bold,

self-assured central figure and the doodled imaginings around it encapsulates the oppositional forces that run through all of Connell's work. Time after time in her work, the rational is confronted by the irrational, the intellectual by the sentimental, the internationalist by the regionalist.

These are polarities that for Connell have never been resolved, pivoting as they do on the complexities of the human spirit and the perpetual clash of cultural norms. Connell has never wavered in placing human experience at the center of her work, for not to do so would go against everything she has ever been and everything she has ever believed. Yet, the artistic and cultural influences she has witnessed over most of the twentieth century have fluctuated widely in the value they placed on that experience, ranging from the postslavery era in the South to the women's movement. In an effort to give form to the social changes and the tensions they produced, Connell extracted what she felt was necessary from advanced art trends, incorporated it into her own sense of self, and evolved a style of art unusual for its originality and integrity. Her deftness at creating multilayered worlds, at giving visual articulation to the dense intangibles, specifically of southern culture but of contemporary life in general, is what will make her art live.

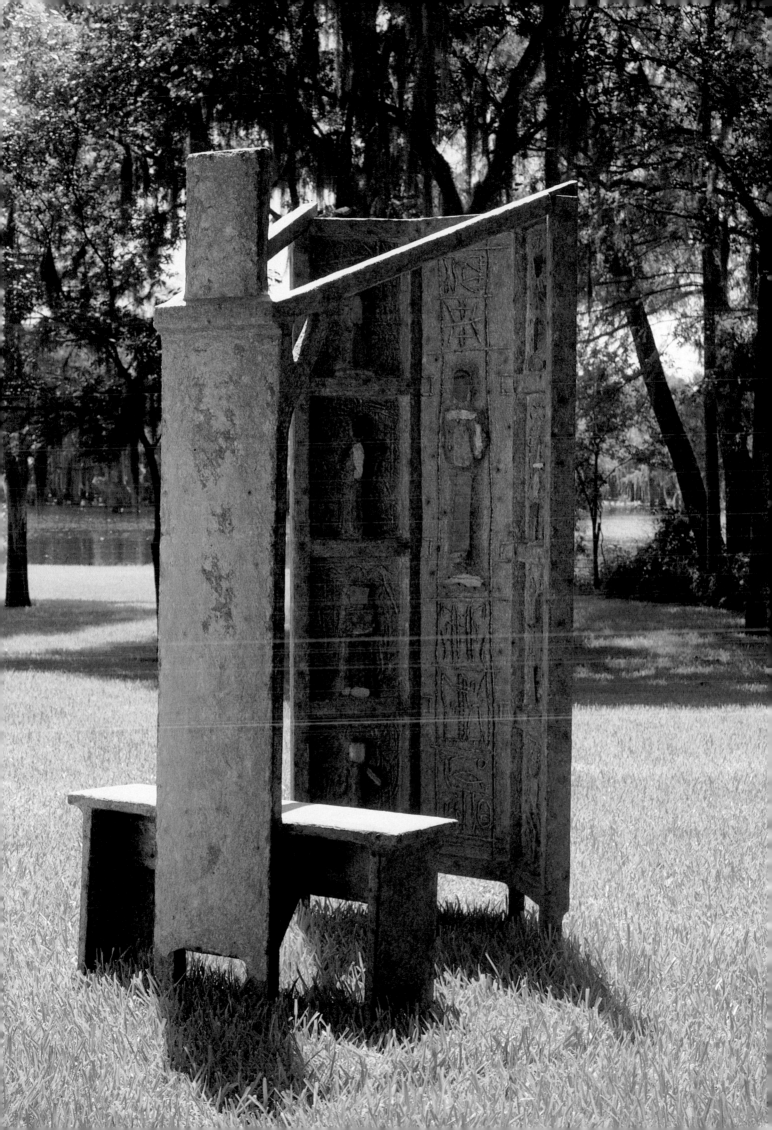

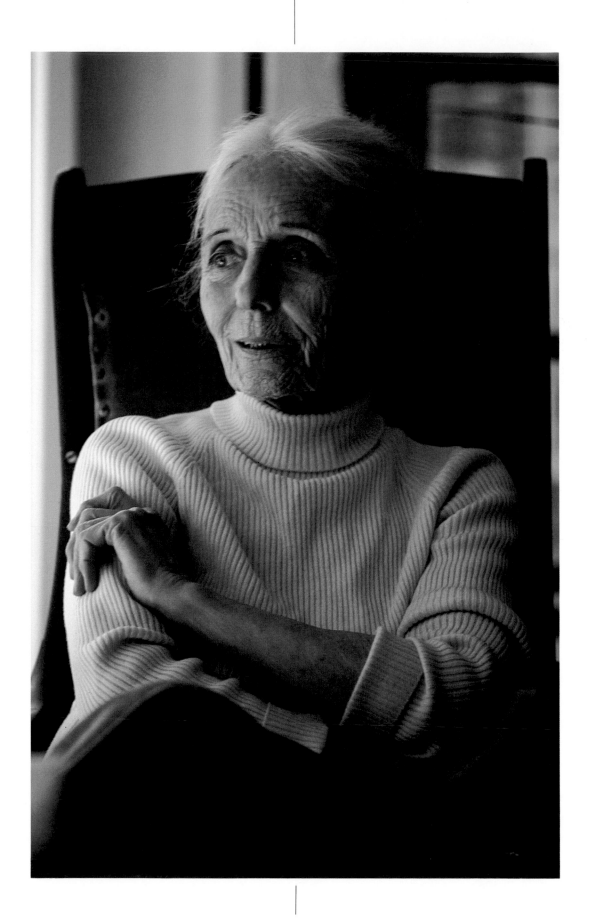

Clyde Connell on Her Art and Life

I forget myself when I'm making art, I forget everything, I really do. I think that any kind of work that lets you immerse yourself is good. The works enlarge because of that immersion. Under those conditions, of being immersed, it's an experience that's not just enjoyment. The inner eye can be the mind's eye. Art would be a healing process if you were already an artist. When you think of Eva Hesse when she got back into her art during periods of illness, it helped heal her mind. I haven't used art as a healing force but I know this. If I'm kept away from working, it makes me ill, like something's wrong. I'm frustrated when I can't get to work. I feel that way if I have to go to exhibits and places longer than two months or so. All I want to do is to get back to work.

With my art, which I think about almost all the time, I feel I haven't reached what I should be reaching at my age. Also, I feel that almost every artist has in his time what is potentially his best work. Anything he does after that isn't quite there. I don't know if I've reached that stage and gone through it. I think it came in the Habitats and just after but I'm still trying to find by myself what I want to do. Resolution is the result of trying to think things through. My type of person takes being quiet and being alone. I like being alone. In making a change, I have to have lots of solitude to let things form.

My concepts evolve out of philosophical determination or thinking about things. That's the way the Habitats came. Let's go back to my first sculpture. I had to get settled in my thinking about what had happened or how I was going to take it on, and out of that grew a wish to do sculpture. I wanted it to relate not to a specific incident or anything, but to be out of real experience. I kept thinking about Faulkner and how different his work was.

I used to be very timid. I feel that way about myself, about doing things in strange situations. I'm just glad I can do it now. It took me years to get over being timid, of being afraid of strange situations. I was taught to be afraid of storms. A tornado came through when I was two or three years old and we went down into the storm cellar. I thought you were supposed to be afraid, then I found out you don't have to be.

Nobody stays still. I don't stay still in art, in life, in thinking, in feeling. I don't think people can stay still. They are constantly going on, either forward or backward. People don't want to stay still. They couldn't, just dealing with change and experience. Everything is movement to me. Sound is movement, thinking is movement. Life is a continual process. The way that I feel about art now is just a continuation of where I've been. You leave one time, of course, but you don't leave certain things. It's the idea of adjustment and continuity, that life prevails.

I don't think you need to know too much about why you do things. I had to think it through, I was forced to think it through [when I moved to the lake]. I just couldn't stop being. I'm surprised at the radical style change Philip Guston went through at the end of his career, but I think he must have "gone through" and finally came down. Perhaps he felt that the new style was more realistic to him than straight abstract expressionism. It shows more the personality of the artist.

Relationships have always been a big part of my life. Sometimes the best relationships are the ones that don't have to go too deep or be too tragic. Just positive, not negative. That's what I like to work on. I don't like everybody and not everybody likes me. It would be a boring world if everybody was the same.

Arthur A. Garvey was one of my philosophers. One of the books he wrote was on response and about the importance of being detached. To become detached, an observer standing off and looking at life, has really helped me quite a bit. There must have been something there that naturally appealed to me.

What surprises me is how many young people like my work. I'm so much older than they are. I don't see too many old people. In my experience, when you get to my age, it's rare that I see anybody my age. Few older people see my work.

Opposite page:
HABITAT I, *1977*
Mixed media, 86 × 17 × 15 inches
Private collection, Shreveport, Louisiana

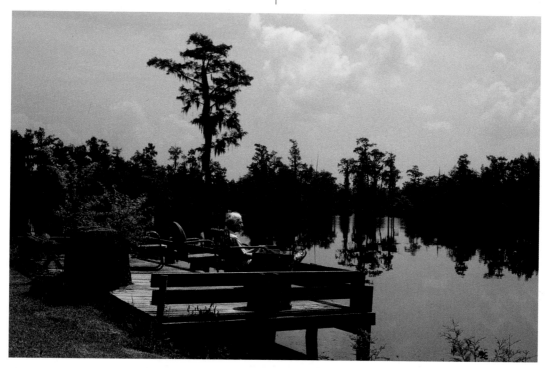

Connell sitting on her Lake Bistineau pier, 1980

I was raised in the Christian church and I taught there. I can almost quote the King James version of the Bible word for word. I believe there were lots of things I couldn't understand. I couldn't understand it until I began to read an Indian poet named Tagore. He made a Christian out of me. It wasn't Zen or any particular Eastern religion, but he had a feeling about nature and presence. All of that wasn't talked about in the Christian church. I believe that religion should be universal. I think that people try to limit God. To me, God's presence comes more through nature, through thinking, reasoning, and relationships.

My aunt taught us childhood stories. She was a good storyteller. She loved telling us stories about heaven being paved with gold. I couldn't care less about gold. It must be a lonesome place. What do you do walking on streets of gold?

I think we have to have progress. I believe in continual revelation, in the sense that man continues to understand better and to respond. I have a feeling there is an afterlife. Now, what it is, if it's you come back or don't come back, I don't know. It's hard for me to believe that a thinking person just disappears forever.

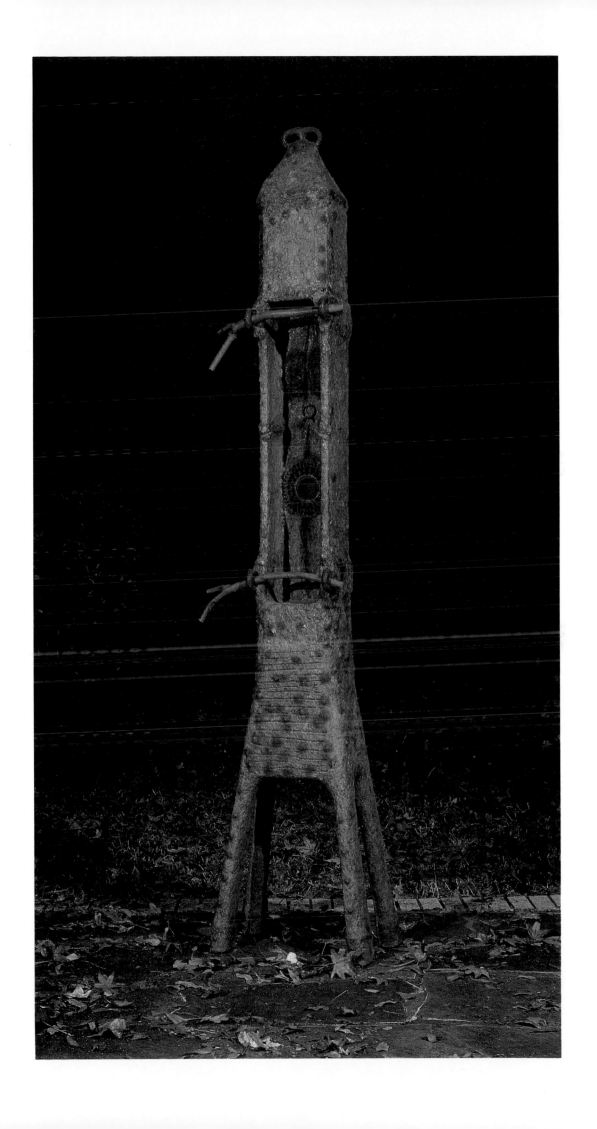

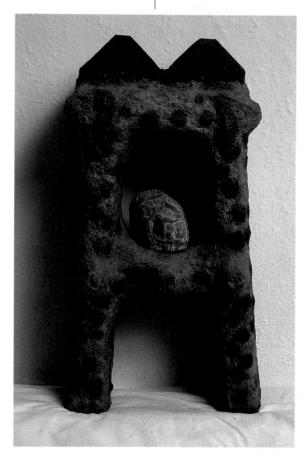

STONE MARKER, 1968
Mixed media, 17 × 8 × 5 inches
Private collection, Shreveport, Louisiana

NUMBERED AND FILED, NO. 1, *1984*
Mixed media, 74 × 32 × 22 inches
Private collection, Shreveport, Louisiana

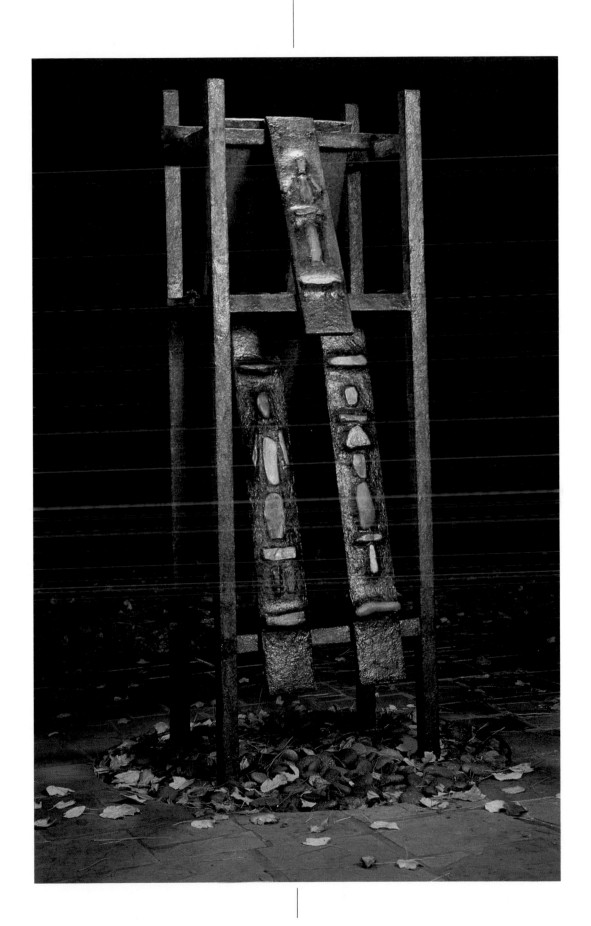

76

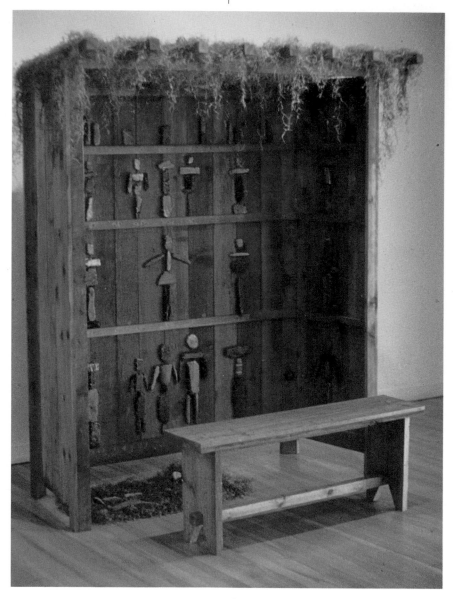

NUMBERED AND FILED, NO. 2, 1984
Mixed media, 82 × 65 × 50 inches
Collection of the artist

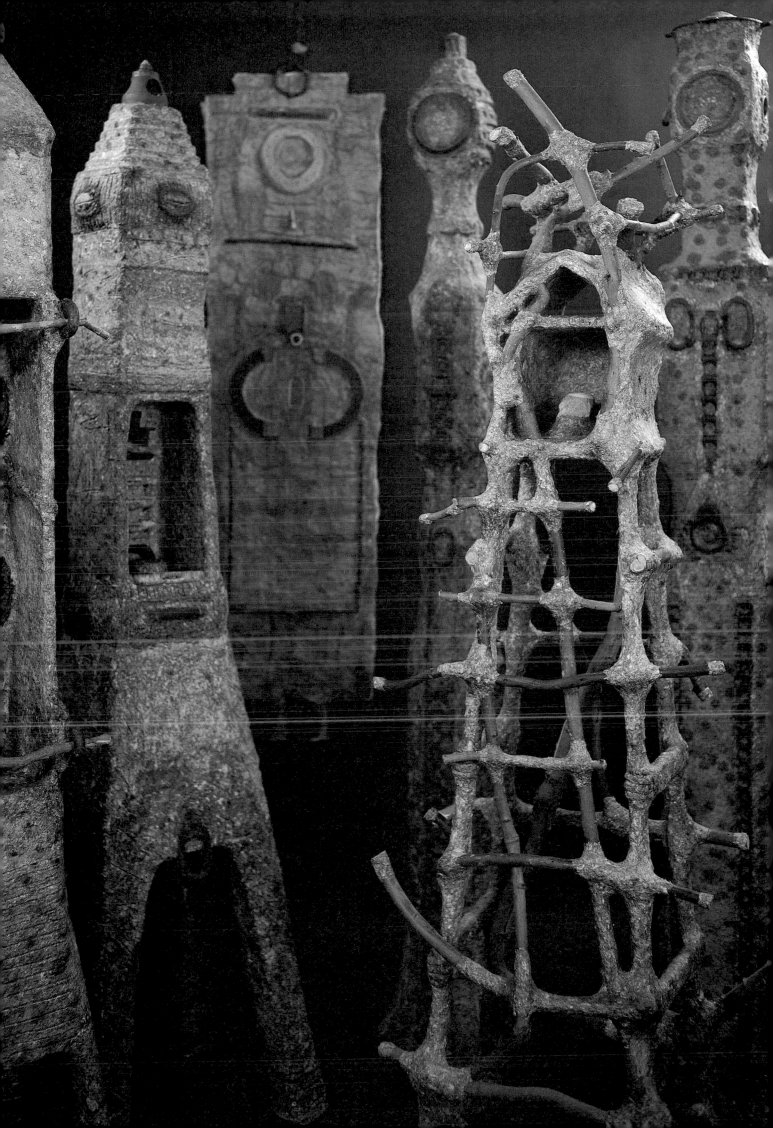

CREATURES OF THE HOT HUMID EARTH, 1987
Inks, acrylics, graphite, and red clay on canvas, 66 × 60 inches
Courtesy Barry Whistler Gallery, Dallas, Texas

PEOPLE PUPPETS, 1987
Acrylic and graphite on paper, 16½ × 12½ inches
Private collection, New Orleans, Louisiana

UNTITLED, *1984*
Acrylic and ink on paper, 30 × 22 inches
Private collection

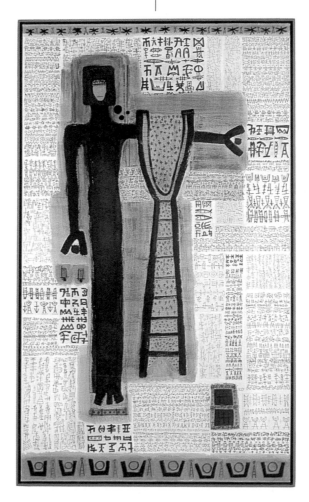

WOMAN WITH MIRROR AND WORLD NEWS, *1984*
Acrylic and graphite on canvas, 72 × 42 inches
Private collection, Koran, Louisiana

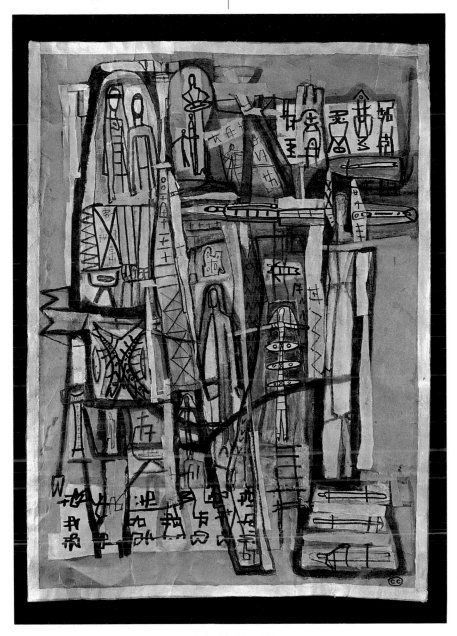

DIALOGUE, 1966
Mixed media collage, 72 × 48 inches
Collection, Worthen Bank, Little Rock, Arkansas

Pages 83–87
BOUND PEOPLE SERIES, 1986
Mixed media, each 72 × 15 × 3 inches
Private collections

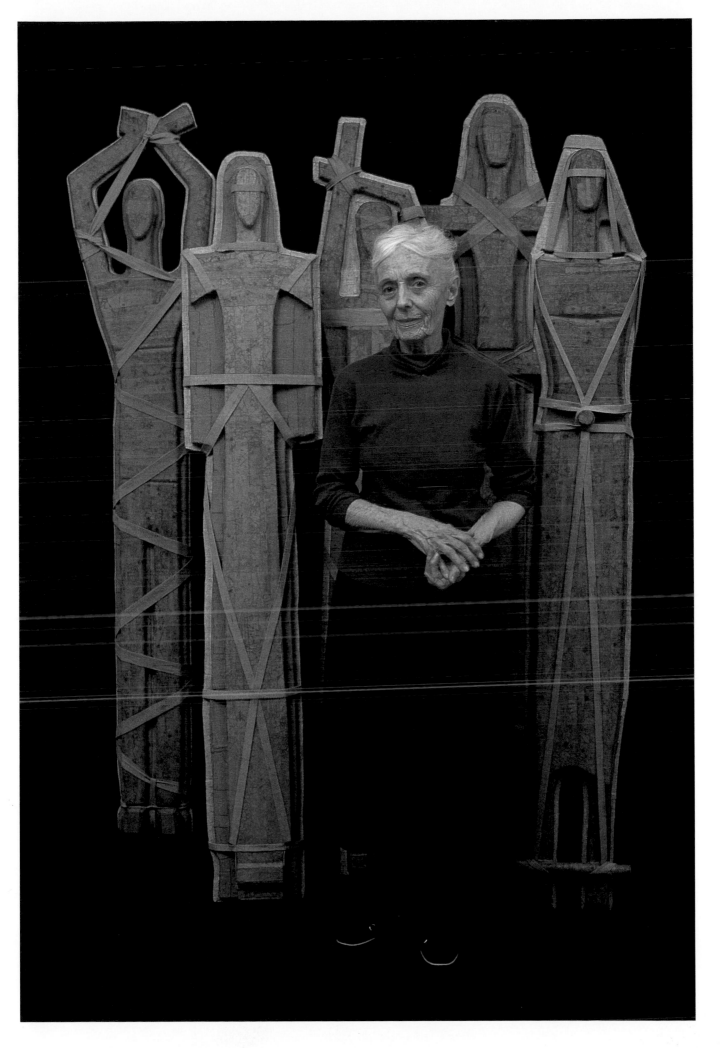

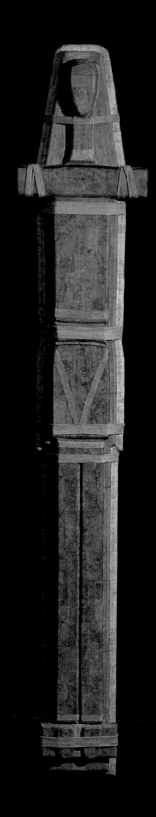

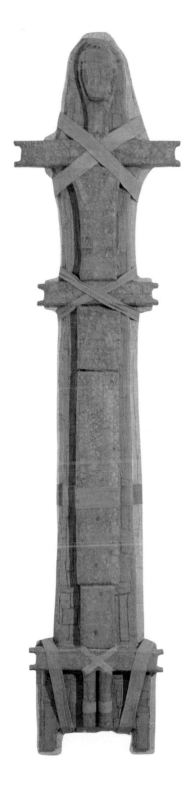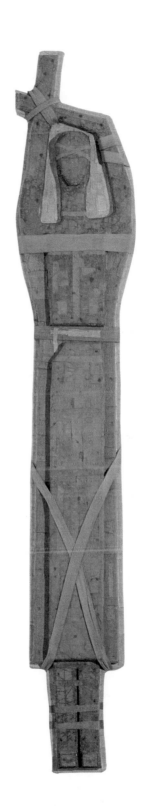

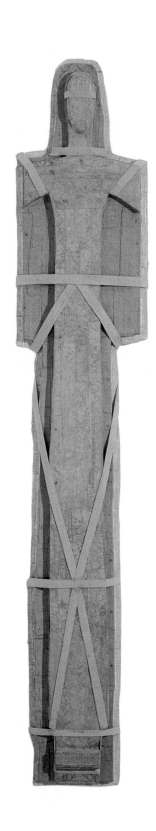
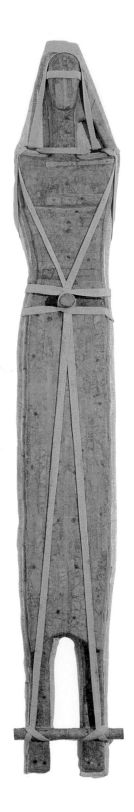

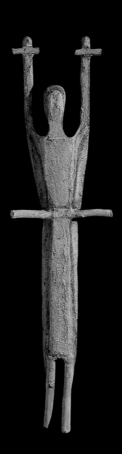

NON-PERSON DANCER, 1986
Mixed media, 20½ × 4 × 4 inches
Private collection, Allentown, Pennsylvania

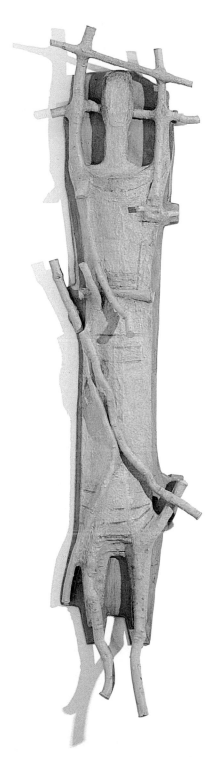

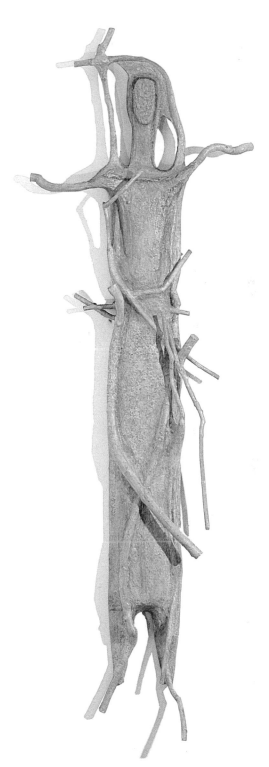

GRAY DANCER, 1986
Mixed media, 69 × 15 × 8½ inches
Courtesy Barry Whistler Gallery, Dallas, Texas

SCARF DANCER, 1986
Mixed media, 71 × 23 × 4½ inches
Courtesy Barry Whistler Gallery, Dallas, Texas

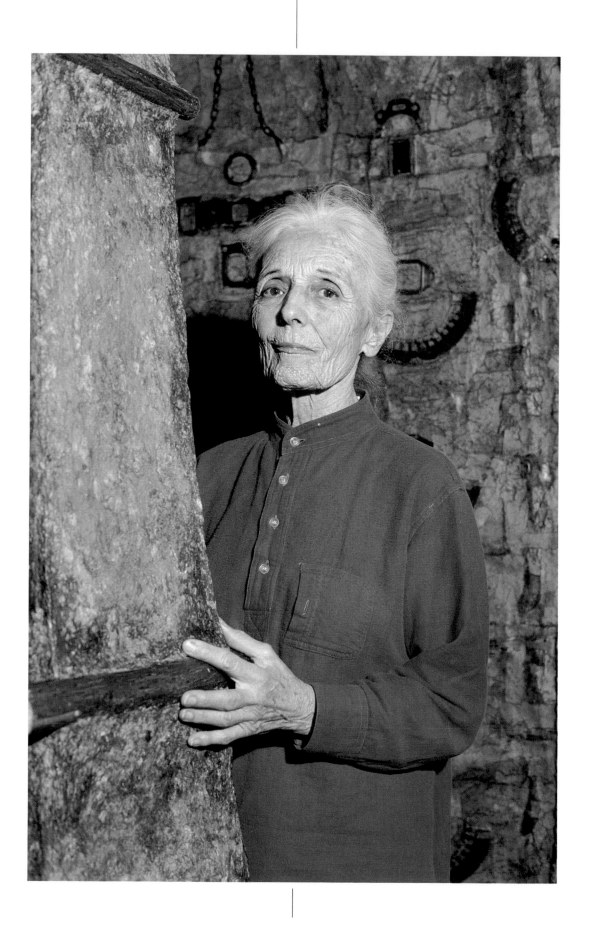

Chronology

September 19, 1901 Minnie Clyde Dixon born on Woods Place, a family plantation in Caddo Parish near what became the town of Belcher in northwestern Louisiana.

1919 Graduates in the second graduation class of Belcher High School, a one-room school.

1919–1922 Attends Brenau College in Atlanta, Georgia, and Vanderbilt University in Nashville, Tennessee.

1922 Returns to Belcher and marries T. D. Connell. The newlyweds move into Clyde's childhood home, Dixon House, after her father is accidentally killed.

1920s Part of a rug-hooking group composed of plantation women. During the decade, Clyde gives birth to three children.

1925 Enlisted to teach Sunday School at Belcher Presbyterian Church.

1930s Enlisted to teach Vacation Bible School in Belcher's black Presbyterian church. Becomes active in the Presbyterian Women of Louisiana, participating in teacher workshops, where she establishes a specialty in children's art.

1940s Family plantations foreclosed on after World War II, with only Dixon House in Belcher remaining family property. Clyde takes a job as program director at the Shreveport YMCA.

1949 T. D. Connell appointed superintendent of the Caddo Parish Penal Farm in Greenwood, Louisiana. The family leaves Belcher forever. At the penal farm, Clyde gets her first permanent studio.

1952 Clyde elected president of the Louisiana Presbyterian Women. She becomes active in church involvement with civil rights. She begins her series of prisoner woodcuts, introducing social realism into her work.

1954–1962 Elected a southern delegate to the Home Missions Committee of the National Council of the Churches of Christ, which meets twice annually on the East Coast. Her regular visits to New York galleries and museums start. Abstract expressionism makes a major impact on her concept of art.

1954 Helps found the Contemporary Art Group in Shreveport.

1955 Contemporary Art Group has its first exhibition at the State Exhibition Museum at the Louisiana State Fairgrounds in Shreveport. Work by Connell included. She makes her first forays into abstract painting with the Vertical Series.

1959 T. D. Connell loses his job at the penal farm. The couple moves to a fishing cabin on Lake Bistineau, a swampy recreational lake seventeen miles southeast of Shreveport in Bossier Parish. Clyde enters a period of seclusion.

1960s Clyde first develops the Sunpath motif. She introduces collage into her painting.

1970s Begins work on Swamp Songs, collaged wall hangings, which contain the first surrealist influences. As an outgrowth of collage, she experiments with papier-mâché as a sculptural material because she cannot afford steel.

	Earth Figures, her first papier-mâché sculptures, are made between 1970 and 1973.
1971	Exhibits in group show sponsored by Contemporary Art Group.
1972	Exhibits in the Invitational Craft Exhibit at Barnwell Art Center, Shreveport.
1973	First one-person shows at the Louisiana State University campuses at Alexandria and Shreveport.
1974–1976	Represented by Bauman Gallery in Los Angeles.
Late 1970s	Joins with other progressive Shreveport women artists in renting an old office building on Cotton Street in Shreveport to share as studio space. Begins Post and Gate Series of sculpture around 1975. Begins Non-Persons Series of wall hangings in 1977.
1976–1979	Cotton Street artists invite four national women in art to speak on contemporary art and view their work: Lucy Lippard, Judy Chicago, Jackie Winsor, and Roberta Smith.
1978	Begins Habitat Series of sculpture. Sends slides to Murray Smithers at Delahunty Gallery in Dallas. Smithers visits Connell at Lake Bistineau.
1979	Receives her first one-person shows outside Louisiana at the Tyler Art Museum in Tyler, Texas, and the Lawndale Annex of the University of Houston.
1980	Delahunty Gallery in Dallas begins representing Connell. One-person exhibition at DW [Dallas Women's] Co-op in Dallas.
1981	First one-person exhibition in New York at the Clocktower Gallery. Receives Gottlieb Foundation grant of $10,000.
1982	Second one-person exhibition in New York at Delahunty Gallery.
1985	Receives Distinguished Woman Artist Award from the Women's Caucus for Art in the College Art Association in Los Angeles.
1986	Receives Award in the Visual Arts from the Southeast Center for Contemporary Art and shows in AVA national touring exhibition.
1987	Honored by National Sculpture Conferences: Works by Women, Cincinnati Contemporary Art Center.
1988	Shows in Different Drummers, Hirshhorn Museum of Art, Washington, D.C.

Bibliography

Adams, James Luther. *Paul Tillich's Philosophy of Culture, Science, and Religion*. New York: Harper & Row, 1983.

Adolph Gottlieb: A Retrospective. New York: Arts Publisher in association with Adolph and Esther Gottlieb Foundation, 1981.

Bachelard, Gaston. *The Poetics of Space*. Boston: Beacon Press, 1969.

Becker, Howard. *Art Worlds*. Berkeley: University of California Press, 1982.

Calkins, Gladys Gilkey. *Follow Those Women: Church Women in the Ecumenical Movement*. New York: National Council of the Churches of Christ, 1961.

Chicago, Judy. *Through the Flower: My Struggle as a Woman Artist*. New York: Doubleday & Company, 1975.

Corn, Wanda. *Grant Wood: The Regionalist Vision*. New Haven: Yale University Press, 1983.

Dabney, Virginius. *Liberalism in the South*. Chapel Hill: University of North Carolina Press, 1932.

Dewhurst, C. Kurt. *Artists in Aprons: Folk Art by American Women*. New York: E. P. Dutton, 1979.

Dirks, J. Edward. "About the Journal." *Christian Scholar* (Somerville, N.J.: National Council of the Churches of Christ) 36, no. 1 (March 1953): 3.

Douglas, Ann. *The Feminization of American Culture*. New York: Alfred A. Knopf, 1977.

Geertz, Clifford. *Local Knowledge*. New York: Basic Books, 1983.

Kandinsky, Wassily. "The Problem of Form." In *Voices of German Expressionism*, ed. Victor H. Miesel. Englewood Cliffs, N.J.: Princeton University Press, 1970.

Kiesler, Frederick. *Inside the Endless House*. New York: Simon & Schuster, 1966.

King, Richard H. *A Southern Renaissance: Cultural Awakening of the American South, 1930–1955*. Oxford: Oxford University Press, 1980.

Krauss, Rosalind E. *The Originality of the Avant-Garde and Other Modernist Myths*. Cambridge, Mass.: M.I.T. Press, 1985.

Kuspit, Donald. "Sol LeWitt: The Look of Thought." *Art in America* 63 (September–October 1975): 42–49.

Lippard, Lucy. *Eva Hesse*. New York: New York University Press, 1976.

————. *From the Center: Essays on Women's Art*. New York: E. P. Dutton, 1976.

————. *Ocular 1549* (Denver), September 1977, pp. 39–42.

————. *Overlay: Contemporary Art and the Art of Prehistory*. New York: Pantheon Books, 1983.

Livingston, Jane, and John Beardsley. *Black Folk Art in America, 1930–1980*. Jackson: University Press of Mississippi, 1982.

Mathews, Donald G. *Religion in the Old South*. Chicago: University of Chicago Press, 1977.

Mays, Benjamin Elijah. *The Negro's God*. New York: Negro Universities Press, 1969.

Moser, Charlotte. "Texas Museums: Gambling for Big Change." *ARTnews*, December 1979, p. 96.

O'Connor, Francis V. "Albert Berne and the Completion of Being: Images of Vitality and Extinction in the Last Paintings of a Ninety-six Year Old Man." In *Aging, Death, and the Completion of Being*, ed. David D. Van Tassel. Philadelphia: University of Pennsylvania Press, 1979.

Ricoeur, Paul. *History and Truth*. Evanston, Ill.: Northwestern University Press, 1965.

Robins, Corinne. *The Pluralist Era: American Art, 1968–1981*. New York: Harper & Row, 1984.

Rubin, William, ed. *Primitivism in 20th Century Art: Affinities of the Tribal and the Modern*. New York: Museum of Modern Art, 1984.

Selz, Peter. *New Images of Man*. New York: Museum of Modern Art, 1958.

Shields, Elizabeth McEwen. *Guiding Kindergarten Children in the Church School*. Richmond, Va.: Onward Press, 1931.

Van Tassel, David D., ed. *Aging, Death, and the Completion of Being*. Philadelphia: University of Pennsylvania Press, 1979.

Vlach, John. *The Afro-American Tradition in Decorative Arts*. Cleveland: Cleveland Museum of Art, 1978.

Williams, T. Harry. *Huey Long*. New York: Alfred A. Knopf, 1970.

Wyatt-Brown, Bertram. *Southern Honor: Ethics and Behavior in the Old South*. Oxford: Oxford University Press, 1982.

Photographic Credits

Neil Johnson:

2–3, 27,
28 top, 29, 34 top, 70, 73,
74, 75, 78, 79, 81, 83, 84, 85,
86, 87, 88, 89, 90

Martin Vandiver:

Frontispiece, 36, 42,
43, 44, 45, 46, 47, 48, 52,
56, 57, 58, 59, 60, 61, 63, 64,
65, 69, 77

94